The New Testament

The New Testament

Through 100 Masterpieces of Art

Régis Debray

MERRELL

LONDON · NEW YORK

Introduction

Our present culture generally agrees that art can be an opening onto the world of the spirit—that mere appearances can be visual thresholds to the world beyond the veil of appearances. However, we must bear in mind that conditions leading to the emergence of an art as a visual gateway to the divine have not been present in all cultures; also, that in monotheistic culture the creation of such an art, which in retrospect appears as a mighty achievement, came about because of specific historical forces within the Christian tradition and was the work of certain Christian theologians and artists audacious enough to believe that sensual experience could be expressed through what might loosely be termed the magical force of visual forms.

There are great historical Jewish and Islamic artists and a specifically Islamic esthetic. But the New Testament is a chief factor in the emergence and development of art as the realm not only of excellence but also of personal expression. Historically, it was a schism in monotheistic orthodoxy resulting from Byzantine theology that enabled the modern West to become "the civilization of the image," and, as such, the planet's dominant civilization. From the planet's point of view, given the power the dictatorship of the visual has gained over thought (and, indeed, over imagery), perhaps the triumph of the image is at the very least a mixed blessing. But to lay its evils on religion's doorstep is both facile and wrong. True, the video-sphere under which we live as though under a political, spiritual, and physical state is real; its existence as an established fact is undeniable. And yes, we can trace it back through Renaissance

4

painting to its antecedents in sacred Byzantine icons. But it would be an intellectual error to blame both popular culture's debasement of the Judeo-Christian ethic and the idolatry that informs so much of the current state of popular visual culture on the Byzantine theologians who, by their decrees, made it possible for the soul to find a way to the One Eternal God through lines and colors, and for the faithful to follow the ways of God through imagery. That eighth-century theologians understood the power of imagery to bring the soul to a contemplation of matters urgent to itself is one thing. That men and institutions comprising men have abused that power for corrupt purposes is another thing altogether.

Opposition to religious imagery began in the Greek Church at the end of the seventh century. Enemies of imagery, *iconoclasts,* gained power, especially in the Byzantine court. In 726 the Emperor Leo III banned all religious statues and icons as idols, and the ensuing public controversy shook the Byzantine world. Supporters of imagery, *iconophiles,* came largely from the ranks of the Church, from the highest prelates to simple monks, but were also found at court. It was the widowed Empress Irene, in fact, who in 785 convened a great Church council to reconcile the hostile parties in favor of imagery. The council was held in the Asia Minor city of Nicaea, near Constantinople.

At this, the Second Council of Nicaea, the conciliatory Fathers stipulated by decree that the veneration of icons was not idolatry because "the homage paid to the icon proceeds to the prototype," that is, to Christ, the Virgin, or the saints represented by the icon. The decree also denied that homage to the

icon "will come back to deny the Incarnation of the Word of God." Thus legitimized, the Byzantine icon was able to resist continuing strong attacks from the court and army. And the icon in turn liberated religious art from both the repetitive interlacings on the capitals of church columns and the involutions of calligraphic celebrations of the godhead.

The flame passed from Eastern monasticism to Latin Christianity when Byzantine icon makers, who did not call themselves artists and did not sign their works, crossed the Bosporus and reached Siena and Florence. Shortly before the Italian Renaissance, they became artisan painters. Then, during the early Renaissance, in the early fifteenth century, they evolved into artists in our sense of the word. What followed was the development of Western art as we know it.

These "hundred masterpieces," then, are trophies of a long but worthwhile battle. *The New Testament through 100 Masterpieces of Art* has implications beyond Revelation to involve the place religious art has made for itself in the sensuous world and the adventure it lays before the contemporary gaze. Early legends say that St. Luke, the author of the third Gospel and Acts, Paul's companion on his apostolic journeys, suffered a martyr's death. But later tradition gives him a long life as a painter, doubtless because of his excellence as a literary colorist. Since the Middle Ages, he has been the patron saint of painters.

On occasion, Jews and Muslims found ways to avoid the prohibition of imagery found in their sacred texts. In the Christian world, however, the rise of imagery began when

the Church, arguing from the dogma of the Incarnation of the Word, conferred dogmatic status on religious art. But as the conclusion to be drawn from this dogma went against certain other tenets, a forceful conceptual argument on the precise nature of the Invisible was required before religious imagery could evolve from such emblems as the vine stock, the fish, the anchor, or the lamb into icons, and from icons into figurative images, frescoes, and oil paintings of a suffering God in the person of Christ—images that do not depart from the Scriptures but, rather, translate sacred text into representative visual images. Once this position was reached, representative Christian art no longer thrived only in scattered oases of legitimacy throughout the Christian world but enjoyed universal official status.

In effect, the West of today has the genius of images because two thousand years ago the first Christians were possessed of the genius of mediation. Through the learned argument of "Christology," they asserted Christ as a middle term, an intermediary between God and man, and applied this principle to imagery. As the reasoning developed, both Christ and images were held to be at the crossroads of the spiritual and the corporeal, and to mediate between the bipolar opposites Creator: creature, Spirit: matter, in precisely the same ways. If we assume that the Word became incarnate in man who was fully man, it logically follows that a material as thick as pigment or colored paste can become "the tabernacle of the Holy Spirit"; if the Son is the visible image of the Father, who is the invisible of the Son, and that God did not deem it impious to assume the form of a material and human body, it should not be impious

for man to produce material and human images of God (at least through such images of his Son, for the Christian consensus has always preferred images of the Son over those of the Father). From this argument came the Christo-morphism of religious painting, which finds its axel and engine in the Gospels' narratives of Jesus's life and acts: his birth foretold to Mary, his infancy, childhood and adolescence; and the adult Christ, preaching, wandering, suffering, and dead.

Always more human, this God, and always more divine, this man. Beginning with the High Renaissance, Christ is depicted progressively more in the company of women. This was a dangerous step for painters to take. In Christian thought, the sin of images was the sin of the flesh, the imagination mistress of error and falsehood; Eve yielded to the serpent's temptation because she believed her eyes; the siren's song was devilry. Precisely for this reason early Church Fathers equated appearances and concupiscence. Tertullian of Carthage (160–220), who deemed idolatry "the greatest crime of the human race," was a rigid anti-feminist, the fierce enemy of makeup, perfume, long hair, and immodest dress. Centuries later Calvin echoed him in the *Institutes* (1536): "Man never begins to worship images without conceiving some fleshly and perverse fantasy."

This explains in part why the cult of Mary was so intimately involved with the fate of imagery. The Virgin appears a thousand times more in pictures than in the Gospels. Acts does not mention her. Byzantine iconoclasm rejected the cult of Mary along with images, yet it was under the Virgin's aegis, with the

support of the dowager empresses Irene (789) and Theodora (843) that Byzantium's marriage of sense and meaning occurred. The revival of religious statuary in the West (*c.* 1000) took place in connection with reliquary statues of the Virgin, set with precious stones. Called *majesties,* some of these objects, like the Majesty of St. Foy of Conques, were often believed to perform miracles. And it is not by chance that the "sinner" Mary Magdalene, neither virgin nor mother, who "loved much," anointed Jesus's feet, and was the first to see Christ's empty tomb, has inspired so many Christian artists, notably during the Counter-Reformation.

Long before the Counter-Reformation, Pope Gregory the Great, who enthroned imagery in the West, also rescued the Magdalene from hell by declaring his devotion for her. "The image is the Bible of illiterates," he proclaimed in 600 (Letter to Bishop Sirenus of Marseilles), and of Mary Magdalene he said, "Loving the Truth, she washed away the blemish of her sins with her tears" (*Homilies on the Gospels,* 25). It is as though, in legitimizing the art of painting, Gregory also gave later painters one of their favorite themes. And in effect, painters responded with a gift of their own. It was they who created our myth of Mary Magdalene's life after the Resurrection, of which the Gospels and Acts say nothing. This ambiguous character's road from sin to saintliness, from Eros to Agape, followed in paintings from the *Pietà* of Villeneuve-lès-Avignon (where the former prostitute, holding a large handkerchief, is at the Virgin's left), through Veronese's kneeling woman and Caravaggio's ecstatic one to Georges de la Tour's *The Magdalene Repentant,*

where she sits, bathed in candlelight, contemplating a skull, the symbol of penitence.

Still, imagery was embattled, and not only by those who saw imagery as idolatry. The Renaissance was also the age of humanism, one of whose dominant philosophical systems derived from Plato, who relentlessly denounced art as a lie and asserted the impotence of images as intermediaries between the heaven of abstract ideas and the concrete world of men and things. But painters, by virtue of their practice, asserted metaphysical beliefs quite to the contrary of Plato's, namely, that the material substance of paint could be a vehicle of the Holy Spirit and that a pictorial language could convey the Truth of the Scriptures (provided that the image adhere closely to the text).

Supporting painters was the Church, with its pedagogical imperative "to teach the illiterate what Scriptures teaches the educated" and its wish to appropriate painting's political power, which is integral to imagery's emotive force. In Matthew, Jesus's last words to the Apostles are, "Go therefore and make disciples of all nations … teaching them to obey everything that I have commanded you." In the Renaissance and Counter-Reformation, the church effectively converted the pictorial translation of the Scriptures, born in the late Middle Ages, into an iconic production, a means for the conversion of souls.

Painting's effective sphere is that of action. Images move us; we speak of their "shock" or "impact" on us; they touch the viewer's sensual being; they evoke the presence of a person or an object and therefore involve love; therefore, they require a dynamic participation on the viewer's part. Unlike symbols or

signs, images also appeal to the body; thus they involve the viewer's whole being. Consistent with the principle of activity within the emotional sphere of the image, we say that sight "elevates," looking "ravishes," that an image involves the whole person, that it warms and energizes. Loyola, a soldier of God inspired by the Counter-Reformation, urged the faithful to *see* the places as well as the characters in the life of Christ, "not only to *know* the Lord better but the better to *love* and *follow* Christ." And his army of Jesuits deliberately fed the fires of the sensuous imagination via images. Thus in history, imagery, the "Bible of idiots" dear to Gregory the Great, the *aide-mémoire* of substitution, was more than a liturgical celebration of faith's timeless mystery. It was also a veritable propulsive force, via the affective catalyst of the will. Whereas in the Greek Church the beauty of the spiritual remained contemplative, in the Latin West it was hortatory, leading, and militant to a degree that fell just short of physical warfare. The metaphorical "war of images"—of vision as an operative force and a source of power—brought more than one disbeliever to belief.

When we contemplate reproductions of religious paintings we are always prey to a misconception, that of taking them for works of art. With paintings before the Renaissance this would be an anachronism. Art enters the image when magic leaves it and imagery's authorized and collective devotional, didactic, and commemorative usages give way to private enjoyment: an every-man-for-himself of looking. Images prior to the fifteenth century become art when one sees a church retable as a museum picture, an ex-voto as an installation piece,

or the gold of an icon as a certain kind of yellow. Up until at least the fifteenth century, a painted Christ on a church's plaster wall was not a fresco to contemplate but an operative image: its function was to call for precise sacramental actions like lighting a candle, bowing, crossing oneself, or prayer. The consecrated and consecrating image is not a representational object but a relational one.

When an Eastern Orthodox believer looks at an icon of the Virgin, he feels himself to enter into a relationship with the Virgin's person. He focuses on *her*, not on the painted image's plastic qualities of drawing, tone, or finish. His gaze is also an encounter, for the image also gazes back at him. The flow goes from within the icon via the eye, making the truths of faith shine out toward the observer. To the faithful, the light that seems to originate within the icon and bathe the image of the Virgin with its brightness does not serve to model the features of the Virgin's face or the folds of her drapery. Rather, it carries divine energy from her to the soul.

The icon, therefore, is *more* than a symbol of the Virgin. Representing her unique person, it is itself unique, non-interchangeable. Nonetheless, it remains *less* than an idol. It is only a medium, facilitating the soul's passage from the profane world before the icon through the image of the Virgin to the sacred realm beyond. The painted Virgin is not Mary but a necessary relay point for whomsoever wishes to commune with the Mother of God. Given these conditions, to see is to participate in the divine light incarnate in the icon's nimbus, rays, and golden background. Taste, delectation, and esthetics

are not pertinent concepts. As Gregory Palamas (1296–1359) said, it is a matter of oneself becoming the light.

When, in the twelfth century, Byzantine painter monks came to Italy from Constantinople and the icon began to spread throughout the West, the gold of the St. Foy Majesty stopped being seen as a precious material and became a vehicle of the aura. And when St. Thomas Aquinas constructed his theory of the Beautiful a century later, "beautiful" did not mean to him what it does to us. To Thomas, the Beautiful was an attribute of God, the splendor of his truth, the external and visible face of his intelligible reality. Integrity, proportion, clarity, and harmony were not the imaginative splendors of an art work or expressions of a singular artist's unique touch and recognizable style but the characteristics of God's intellectual perfection.

The illusionist fiction came into its own only when the layman's gaze stopped passing through the simulacrum of the painting to the sacred prototype beyond it. Until Giotto, gold was not a color. It was the living radiance of the very body of Christ and the *Theotokos,* the God-bearer. But in Giotto's early fourteenth-century church frescoes the modeling of the human figures gave Giotto's Christs, Virgins, and saints an unprecedented illusion of three-dimensionality. Giotto's contemporaries were struck by how life-like the frescoes seemed and painting's reference shifted from the sacred world beyond it to the fictional world represented by it. Gold and other colors became the colors of the world.

But the art of the fifteenth century—art as a practice that produces commodities, signed objects that can move from place

to place as they are bought, sold, and collected—is not the child of God but of the marketplace. It was born not in places of worship but near the ports and warehouses, and in the rich bourgeois homes, of cities like Venice, Florence, Bruges, and Amsterdam, emblematic of their era's economic world. The definition of art as "the Beautiful made intentionally," which is part and parcel with modernity, was constructed *with* images of subjects taken from the Old and New Testament but *against* their religious or devout uses.

This estheticization of images, which continued through the sixteenth and seventeenth centuries and received its theory in the eighteenth, when esthetics became an intellectual discipline, is predicated on a withdrawal of the divine from the earthly world. This withdrawal occurred with the Enlightenment's intellectual reorganization of the world, as the philosophers of the Age of Reason asserted intellectual man at the center of the intellectual world. In this view, man is the unifying point of all perspectives on the world, and master and possessor of nature. From such a vantage point, the sacred could only be perceived as being at a very great distance from the world.

The Enlightenment's intellectual achievement was a victory for man but a defeat for God. It was also in effect a return to mythology, but one without deities, acts, or miracles. As one never destroys what one has merely displaced, the twentieth century saw the spread of a new lay and secular religion, the religion of art. In direct proportion as churches lost worshippers, museums gained audiences. At the same time, the museum became the sanctuary of agnostics. The desacralizing of creations

led to the sacralizing of creators. Thousands of signs attest this, notably the appearance in the discourse surrounding art of such terms as "epiphany," "calling," "ineffable silence," "pilgrimage," and other words and phrases formerly belonging to the vocabulary of the most traditional piety, together with the vibrato and lyrical effusions associated with them.

None of the foregoing keeps us from projecting our present moment's categories onto reliquaries, treasures, frescoes, retables, and other pious objects from past eras that were unaware of our concerns, or from annexing salvation's precious objects to an esthetic realm of no concern to salvation itself. But no more does our retrospective (and somewhat abusive) encoding, which, via a mental shifting of horizons, has led the present moment to regard these historical objects as works of art, oblige us to confuse the realms of art and faith. Yet we do confuse them, as we do with objects of faiths other than Christianity. Our estheticizing gaze extends not only to the Infant Jesus at the Temple and the Virgin of Sorrows but also to the fetishes of black Africa. It removes pious objects from both the sanctuaries of Europe and the huts of Africa and places them in the privileged spaces of the museum. In the process, the nature and qualities of the objects change. The West collects and deals in fetishes, transports them, mounts them on pedestals, lights them, and charges admission to see them. If this is not indeed a distortion it is at least a metamorphosis. An object that, for the seventeenth-century African who venerated it, was a means of communing with his ancestors or the cosmos became a curiosity in an eighteenth-century European collector's cabinet, then a demonic

idol to nineteenth-century missionaries, then, to twentieth-century anthropologists, a piece of ethnography in a museum of man. It continues its career in this century as a masterpiece in a museum of primitive art, where it awaits future recyclings.

Religious art in the great tradition represented by this volume has not survived the twentieth-century demise of figurative art generally. To this writer's knowledge, no ambitious twentieth-century painter from the Fauves through painters exhibiting in today's art world has painted the Trinity. The motif of God the Father as a crowned patriarch seems to appear only as an object of derision, and Jesus has become a subject of kitsch photographs in an intentionally exaggerated style based on that of advertising photography.

However, the twentieth century's separation of imagery from faith is not decisive. There are indications that the imagination of the twenty-first century is "recharging" itself with religious values and in the process searching backward through the Western imagination to its pre-twentieth-century productions. The signs indicate that the sacred, true to itself, is going its own way, without needing conciliar decrees such as Nicaea's or the blessings of academic orthodoxy, which often only recognizes art that it can predict. If these signs are true they are also reassuring, for they indicate that religious art, avoiding clichés of imagery developed by the technology of mass production for the mass media, is operating outside of the dominant commercial culture's "order of the visual" and disclosing a strangeness beyond that of both mass imagery and past religious art: a strangeness beyond memory. The visual, said Serge Daney, is that which

happens to sight when one no longer wishes to encounter anything or anyone else.

Why "strangeness"? The spiritual is not the familiar. It often comes *in* everyday life but is not *of* it. To the contrary, it is an unforeseen encounter with something, or someone, that shakes the soul; a sudden invasion of the soul by something larger than itself. To Moses in a pastoral society it was a burning bush on a mountainside where he was tending his flock; to Paul in the Roman Empire it was a blinding light on the highway to a provincial capital where he was sent by his Jerusalem employers. The Quakers' founder, George Fox (1624–1690), an apprentice shoemaker and baker, had his vision of a cloud of temptation and of the "true voice" that dispelled it, "One morning, as I was sitting by the fire." In our century, with the world virtually in front of our eyes in mass-media imagery, who can predict in what forms encounters with the spiritual will come, and in what forms they will express themselves in art, and in either case stir the soul and lead it to more just awarenesses and actions? The forms of the sacred are, by definition, infinite, inexhaustible.

The history of human experience indicates that in one form or another, coming from one source or another, the encounter with the spiritual is essential. This book is an account of ways in which it came to painters from Matthew, Mark, Luke, and John's verbal accounts of it; and of how, in turn, painters, inspired by the texts, translated them into imagery for the faithful. As such, this volume might also be considered as a prelude to direct encounters with the paintings or the Gospels, or with both.

The Tree of Jesse

According to tradition, David's father, Jesse, dreamed of a huge tree growing out of his chest. Figured on its trunk and boughs were his descendants from his son to the Messiah. Certain Gospel passages that place Jesus in David's lineage, together with the revival of an obscure prophecy in Isaiah, turned this first family tree into a key medieval and Renaissance iconographic motif: a tree, rising from the head or body of a sleeping man and bearing images of David and his descendants; on the topmost branches a Virgin and Child sit enthroned.

Victor Hugo has given us a striking précis of Jesse's oak (attributing the vision, however, to his grandfather Boaz): "A lineage rose up along it like a long chain; below a king was singing, on high a God was dying."

Around the tree, the illuminators of medieval manuscripts traditionally depicted Old Testament prophets who proclaimed the coming of the Messiah.

The Tree of Jesse is an iconographic prologue to the Gospels concerning an event found neither in the Old Testament nor in the New. However, Victor Hugo's simple allusion to it indicates how deeply the image has rooted itself in tradition.

Anonymous French Miniature
c. 1410

The Tree of Jesse with Musical Instruments

The British Museum
London

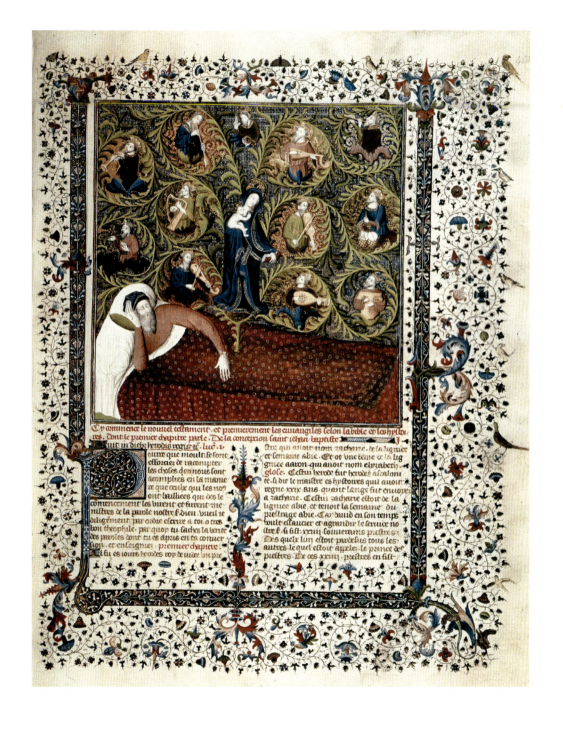

Cy commence le nouuel testament. et premierement les euangiles selon la bible et les hystoi
res. dont le premier chapitre parle. De la conception saint Iehan baptiste.
Huit in diebz herodis regis ãc. luc. i.

Pour que moult se sont
efforcie de racompter
les choses qui en nous sont
acomplies en la manie
re que ceulx qui les nou
ont baillies qui des le
commencement les virent. et furent me
nistres de la parole nostre k dieu. vueil ie
diligemment par ordre escrire a toy o tres
bon theophile. par quoy tu saches la verite
des paroles dont tu es apris en ta conuer
sion. et enseigne. premier chapitre.
Il fu es iours herodes roy de iudee vn pa

Lux qui auoit nom zacharie. de la lignee
et semaine abie. Et ot vne feme de la li
gnee aaron qui auoit nom elyzabeth
glose. Cestui herode fut herodes ascalomi
te. si dit le maistre es hystoires qui auoit
regne .xxx. ans. quant lange fut enuoye
a zacharie. Cestui zacharie estoit de la
lignee abie. et tenoit la semaine du
prestrage abie. Car dauid en son temps
vault et auscier et agrandir le seruice no
tre k si fist .xxiiii. coustumans prestres
des quelx lun estoit pardesus tous les
autres. le quel estoit appele le prince des
prestres. De ces .xxiiii. prestres en fist

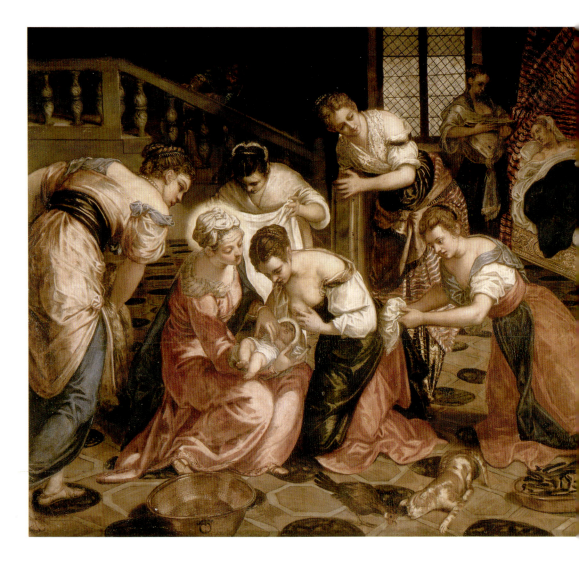

The Birth of Mary

The first account of the birth of Mary occurs not in the Gospels but in the second-century A.D. *Protevangelium*, formerly called the Book of James.

Mary's parents, Anne and Joachim, were "sore grieved" over being childless for twenty years. One day Anne "put on her bridal garment" and walked in her garden. She sat down under a laurel tree and prayed, "O God … bless me … as thou didst bless the womb of Sarah, and gavest her a son, even Isaac." An angel appeared and told her she would bear a child, "and thy seed shall be spoken of in the whole world."

At that moment, messengers came saying angels had also appeared to Joachim and told him, "Get thee down hence, for behold, thy wife Anna hath conceived."

When the two spouses met at a Jerusalem gate, Anne embraced Joachim with joy. Joachim then sacrificed at the temple, "saw no sin in himself," and said, "Now I know that the Lord is propitious unto me."

Although apocryphal, the story has acquired special significance in Christian tradition, according to which the Virgin's birth was immaculate, that is, free from original sin.

Tintoretto
(Jacopo Tintoretto)
1519–1594

The Birth of the Virgin

Hermitage
St. Petersburg
Russia

The Childhood of the Virgin Mary

Mary's childhood is one of the themes of Western painting depicting events that precede those of the four Gospels. The traditional account of the Virgin's infancy and youth, like that of her birth, is found in the *Protevangelium*, which the Church accepts as a pious source. It is also found in the fifteenth-century *Golden Legend*, compiled by the Genoese monk Voragine, which exerted a profound influence on religious iconography.

According to the *Protevangelium*, when Mary began to walk at the age of six months, Anne "caught her up, saying, 'As the Lord my God liveth thou shalt walk no more upon the ground, until I bring thee into the Temple of the Lord.' And she made a sanctuary in her bedchamber and suffered no thing unclean to pass through it."

From this moment, Mary's religious upbringing was diligently attended to by not only her parents but also the priests, scribes, and elders of Jerusalem. A great feast was held for her on her first birthday. When her parents sanctified her in the Temple at the age of three, the priest "made her to sit on the third step of the altar. And the Lord put grace upon her and she danced on her feet and all the house of Israel loved her." Throughout her childhood she "was in the Temple … as a dove is nurtured."

The *Protevangelium*'s account ends with her betrothal to Joseph, which comes about because of a sign from heaven.

A number of paintings, therefore, represent the Virgin being consecrated to God by her parents, the Virgin at the Temple, and the Virgin learning to read.

Francesco Mancini
1679–1758

Saints Anne and Joachim with the Virgin

Galleria Nazionale
dell'Umbria
Perugia
Italy

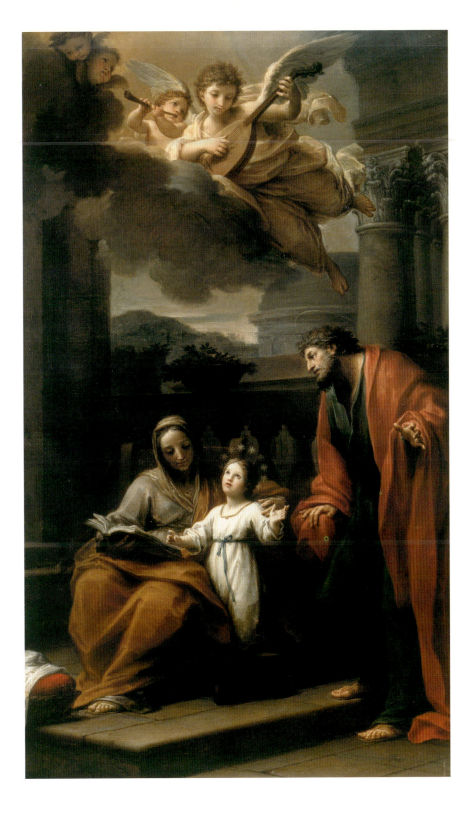

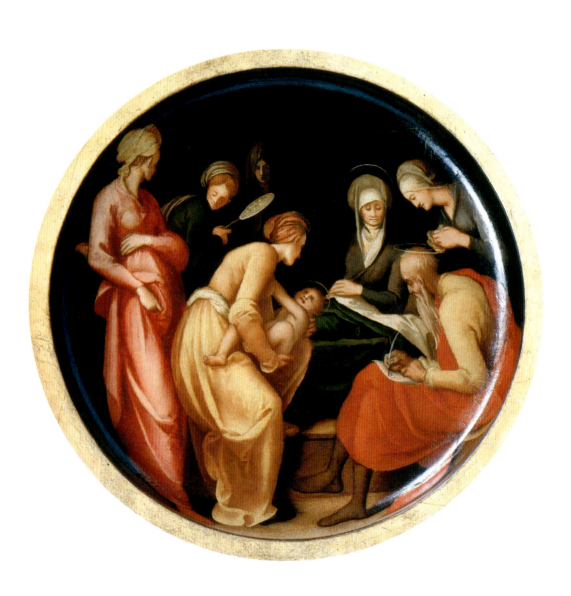

The Birth of St. John the Baptist

Jacopo da Pontormo
(Jacopo Carucci)
1494–1556

*The Birth of St. John
the Baptist*

Uffizi
Florence
Italy

According to the Gospels, the angel Gabriel foretold the miraculous birth of St. John the Baptist in Jerusalem six months before he foretold that of Jesus to Mary in Nazareth.

He appeared to the old priest Zachariah as he was serving in the Temple "at the right side of the altar of incense." Zachariah was terrified but when the angel told him that he and his wife Elizabeth would have a child whom he should name John he was incredulous. "I am an old man, and my wife is getting on in years."

To punish this disbelief, Gabriel struck him dumb and he remained so until the ceremony of circumcision in the Temple.

When the ceremonial moment came for a father to name his son others spoke for him, telling the priests to name the boy Zachariah after his father. Elizabeth spoke up and said, "John," as Gabriel had instructed. The others objected, saying the name was not in their family's tradition. All eyes turned to Zachariah, who wrote on a tablet, "His name is John," whereupon he regained his speech.

The iconography of this theme is greatly inspired by the life of St. John the Baptist construed as a prefiguring mirror of the life of Christ. Therefore, in addition to paintings of the meeting between Zachariah and Gabriel, of the birth of John, and of the moment Zachariah names him, there are also paintings of Elizabeth and the infant John whose poses echo those of Mary and the infant Jesus in paintings under the general title of Virgin and Child.

The Annunciation

Six months after he foretold the birth of St. John the Baptist in Jerusalem, the angel Gabriel descended to Nazareth and told Mary, betrothed to Joseph, that she was going to bear "The Son of the Most High," whose reign would be without end. He specified that the child would be conceived by the Holy Ghost.

He also told her that her formerly barren cousin Elizabeth was in her sixth month of pregnancy.

Mary replied to his message with only, "Here am I, the servant of the Lord; let it be done with me according to his word."

When Joseph perceived that his betrothed was pregnant he thought to repudiate her, but Gabriel appeared to him and said, "Joseph, son of David, do not be afraid to take Mary as your wife, for the child conceived in her is from the Holy Spirit. She will bear a son and you will call him Jesus."

The Annunciation is one of the most frequently represented themes in the history of biblical Western art. The scene always includes a garden, and Mary is almost always shown with a book. There is usually a lily somewhere, either in a vase or, as in Leonardo's painting, in Gabriel's hand. Sometimes Mary, still reading, is unaware of Gabriel's presence; sometimes she looks up at him but marks the page with one hand; sometimes, startled by his appearance, she has let the book tumble to the floor. In some paintings Gabriel is still descending, in others he kneels in his first gesture of greeting, in still others he stands as though delivering his message. Sometimes the scene is turbulent, sometimes preternaturally still. In Robert Campin's altarpiece, the only indication of a moment in time is a whisp of smoke blowing from the wick of a candle that has just been extinguished by the onrush of wind from Gabriel's now calmly folded wings.

Leonardo da Vinci

1452–1519

The Annunciation

Uffizi
Florence
Italy

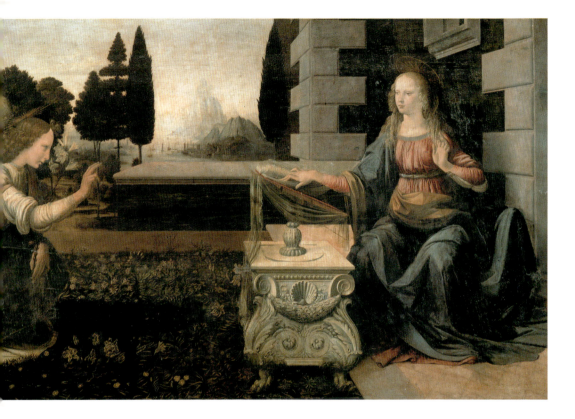

The Visitation

As soon as she had heard Gabriel's "glad tidings," Mary set out to visit her cousin Elizabeth, who, as the angel had said, was six months pregnant.

When Mary entered her cousin's house Elizabeth heard her greeting and felt the child leap in her womb. She immediately understood the significance of the visit and greeted Mary with the words, "Blessed art thou among women and blessed is the fruit of thy womb."

Mary stayed with her cousin for three months, leaving for Nazareth and Joseph's house just before St. John the Baptist was born.

Paintings of the meeting between the two mothers-to-be—she who would bear a prophet and she who would give birth to the Messiah—most frequently show them by themselves. But from time to time Anne, Mary's mother, is also present.

Carpaccio has improvised on the Scriptures by placing the event not inside Anne's house but outside, in a public square, with people all around going about their daily tasks or conversing on high balconies. Nonetheless, the painting is faithful to the intimacy of the scene as it is described in the Scriptures. The numinous moment occurs in full view of over thirty people but no one notices it. It is felt and shared only by Mary and Elizabeth. Therefore the greeting needs no special handling from Carpaccio, no shining light or overt symbolism for its intensity and significance to be felt and shared by the viewer.

Vittore Carpaccio
?1460/66–1525/26

The Visitation

Museo Correr
Venice
Italy

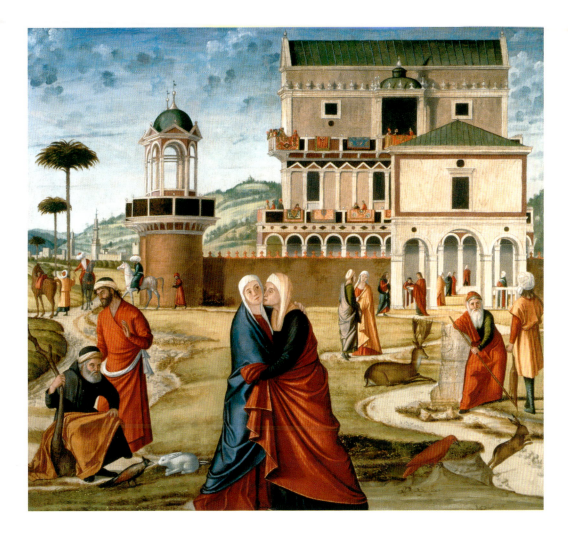

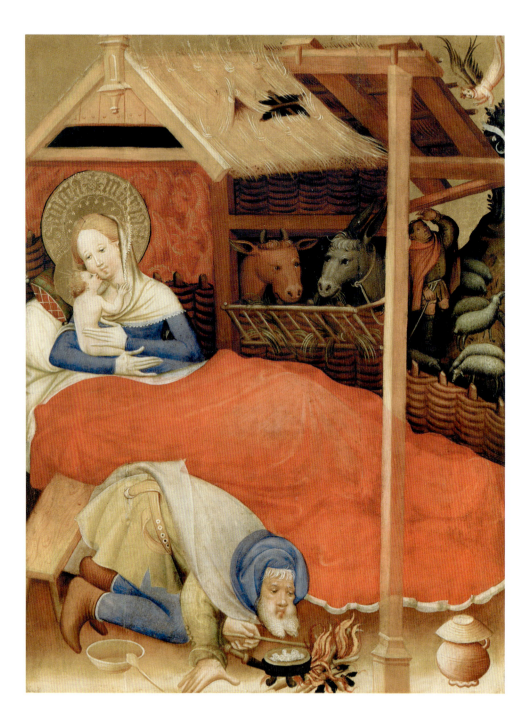

The Nativity

Konrad von Soest
before *c.* 1370–after 1422

The Nativity

Stadtkirche
Bad Wildungen
Germany

Late in Mary's pregnancy, King Herod ordered a census of his kingdom's population, each man to be counted in the city of his origins. As Joseph was descended from David's line, he and Mary went to Bethlehem.

As there were no places in the inns when they arrived there, they sheltered in a stable. Mary's time came that night and so she gave birth in the stable and placed the child in the animals' manger.

In their simplest forms, Nativity paintings show the infant Jesus lying on hay between his adoring parents while an ass or a bull warms him with its breath.

The setting is always a stable, but because of a tradition that originated in the second-century A.D. Book of James, the stable is sometimes set within a grotto.

The Adoration of the Shepherds

According to Luke, on the night of Jesus's birth an angel of the Lord appeared to shepherds watching their flocks in fields near Bethlehem and said, "Unto you this day is born in the city of David a savior which is Christ the lord. This will be a sign for you: you will find a child wrapped in bands of cloth and lying in a manger."

Suddenly the heavens were filled with a multitude of angels singing "Glory to God in the highest, and peace on earth to men of good will."

The shepherds went to Bethlehem, entered the stable, and told Mary what the angels had said.

Tradition has improvised on Luke by having the shepherds bow down and worship the infant Jesus, and poets, dramatists, composers, and painters inspired by tradition have improvised on it further. In the anonymous fifteenth-century English *Second Shepherd's Play*, the shepherds present their simple gifts to the Christ child with plain words of affection and awe: "Hail, I kneel and I cower. A bird I have brought to my babe. Hail, little tiny mop! Of our creed thou art crop; I would drink of thy cup, little day star."

Conflating Luke and Matthew, Ghirlandaio brings the shepherds to Bethlehem a few moments before the arrival of the Three Kings, who are seen with their attendants in the middle ground's sumptuous cavalcade, with men on foot hurrying past them to see the divine child.

Although the moment of the shepherds' adoration is most frequently represented, a number of paintings show the shepherds among their flocks at night, looking up with amazement at a sky of angelic choirs.

Ghirlandaio
(Domenico Bigordi)
1448/49–1494

The Adoration of the Shepherds

Santa Trinità
Florence
Italy

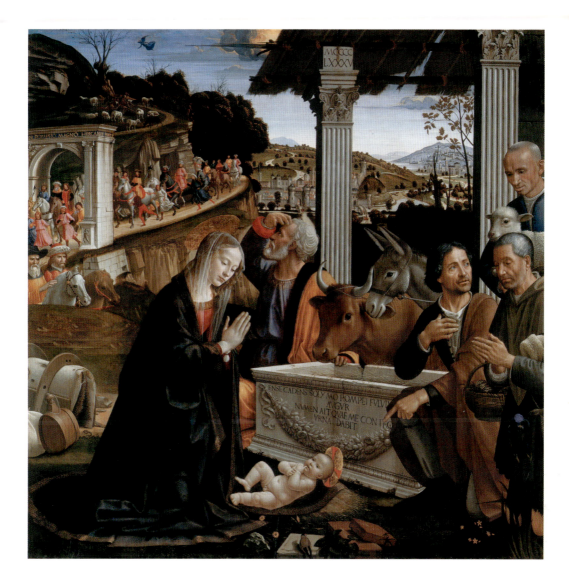

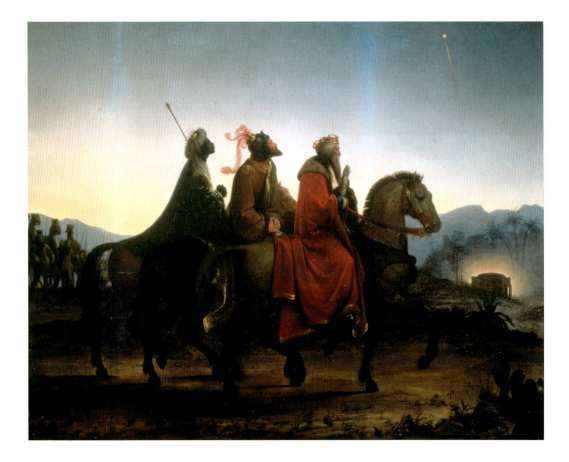

The Star of the Magi

Leopold Kupelwiesser
1796–1862

The Three Magi

Österreichische
Barockmuseum
Vienna

According to Matthew, shortly before Jesus's birth some magi, or wise men, saw a star in the sky foretelling the birth of a king of the Jews. They set out to find him and bow in homage before him. Matthew does not give their names, number, or country. Tradition says there were three magi, one of them black, named Melchior, Balthazar, and Caspar; they traveled by caravan, with many servants, from Arabia and Persia, lands with strong astronomical traditions.

Ahead of the caravan a star or a comet pointed their way.

When they arrived in Jerusalem they visited King Herod. With the openness of learned men who know little about politics, they asked him, "Where is the child who has been born king of the Jews? For we observed his star … and have come to pay him homage."

This undiplomatic question alarmed Herod, but he dissimulated well, convened the chief rabbis and scribes and asked where the Messiah might be born. Citing the prophet Micah, they reasoned that it had to be Bethlehem, the city of David.

Herod told the Wise Men, adding, "When you have found him, bring me word so that I may also go and pay him homage." In secret he was planning an atrocity to rid himself of the newborn king.

The historical Herod the Great was an accomplished diplomat. During the Roman civil wars, when he changed sides he enhanced his power and enlarged his territory. He was a great slaughterer but also a great builder; his principal project was the reconstruction of the Temple about twenty years before the birth of Christ. He distinguished himself as a ruler by establishing peace and internal security. During a famine he sold his golden vessels to ensure the people's food supply.

He died in 4 B.C., shortly after the birth of Christ. It was his son, Herod Antipas, who reigned at the time of the Passion.

The Adoration of the Magi

Led by the miraculous star and the information provided by Herod, the Three Magi came to the Bethlehem stable where Jesus had just been born. They prostrated themselves before the child and "opening their treasures" presented him with the symbolic gifts of gold, frankincense, and myrrh.

Gold represents royalty, incense divinity, and myrrh, used in the embalming of the dead, symbolizes both the universal human fate and the future death of Christ. Indeed, in an anonymous fifteenth-century Adoration play the Wise Man presenting Jesus with myrrh says, "But when thy deeds are done, to die is thy fate. And since thy body shall be buried, this myrrh I will give thee for thy entombment."

(Myrrh is produced by the balsam or balm tree, from which name derives our word "balm.")

A religious rite, then, underlies Matthew's account of the Adoration of the Magi: a ceremony by which the Magi acknowledge the infant Jesus's divine nature. Nonetheless, iconography emphasizes the discrepancy between the Magi's opulence and the nakedness of the baby on the hay. This same discrepancy is seen in a traditional Welsh carol:

> For Jesus our treasure,
> With love past all measure,
> In lowly poor manger was laid.
> Though wise men who found him
> Laid rich gifts around him,
> Yet oxen they gave him their hay

and in verses by the early nineteenth-century French poet José-Maria de Hérédia: "And so Balthazar, Melchior, and Caspar, the Magi Kings, laden with cargoes of silver, vermeil, and enamels and followed by a long train of camels, go forward … ."

Eugène Delacroix
1798–1863

The Adoration of the Magi
(after Rubens)

Dr. C. Werner Collection

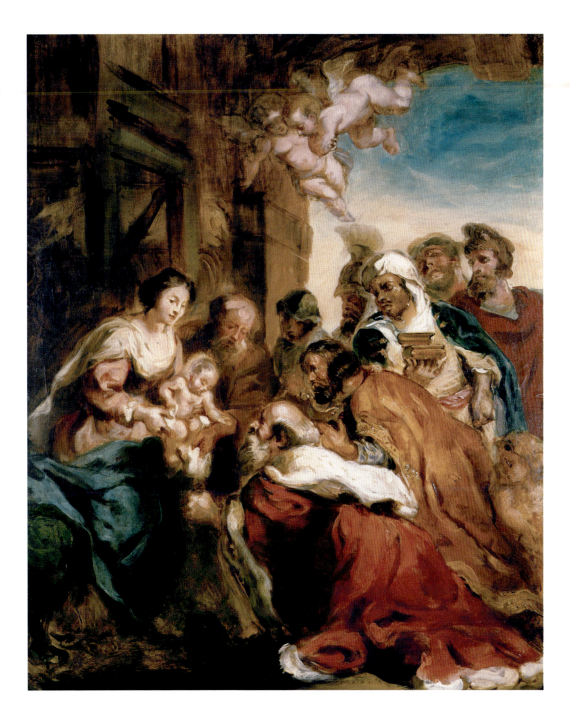

The Slaughter of the Innocents

Warned by a dream that they must not return to Herod, the Magi went home by an indirect route.

After a while, the king understood that he had been deceived and decided to rid himself of this unknown infant rival by a draconic measure. He dispatched his soldiers to Bethlehem to kill all children under two years old in the region.

Thus was realized Jeremiah's prophecy, "Rachel shall bewail her children."

The Holy Innocents are considered as Christianity's first martyrs. They have been given a feast day, December 28, and many churches and a Paris cemetery are named for them. The massacre itself has inspired a large number of paintings. Many great painters have presented the theme of a band of brutal soldiers investing a village.

In Pieter Bruegel the Elder's *Massacre of the Innocents*, set in a wintery village in his native Flanders, the concentration is on the mothers' grief as expressed in commonplace gestures like weeping, praying, and the embracing of children. But as the figure drawing is absolutely specific to each woman, the horror of the event is expressed in terms of many sharply individualized moments of anguish in uniquely imagined human characters. On the periphery, the men, husbands, and neighbors are equally individualized as they turn from the scene, unable to witness it. The man in the foreground leading a dog, together with the background's carts, half-opened door, and footprints in the snow, intensify the horror by referring to the ordinary life of this village: that so peaceful and ordinary a place should be the scene of such unalleviated, violent catastrophe.

Pieter Bruegel the Elder
c. 1525/30–1569

The Massacre of the Innocents

Kunsthistorisches Museum
Vienna

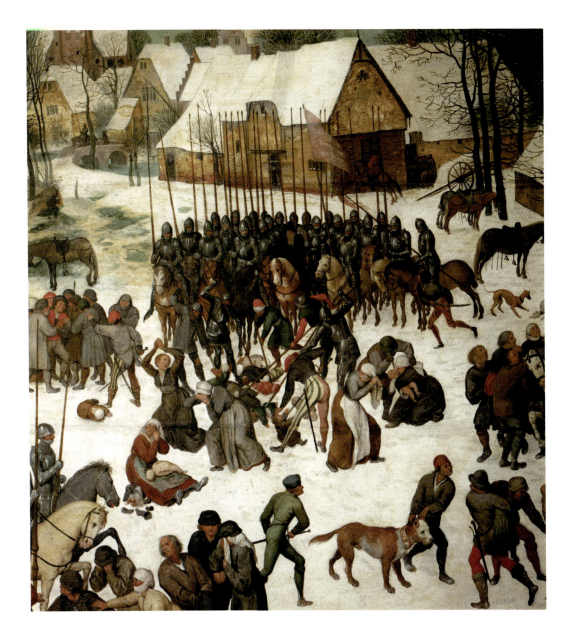

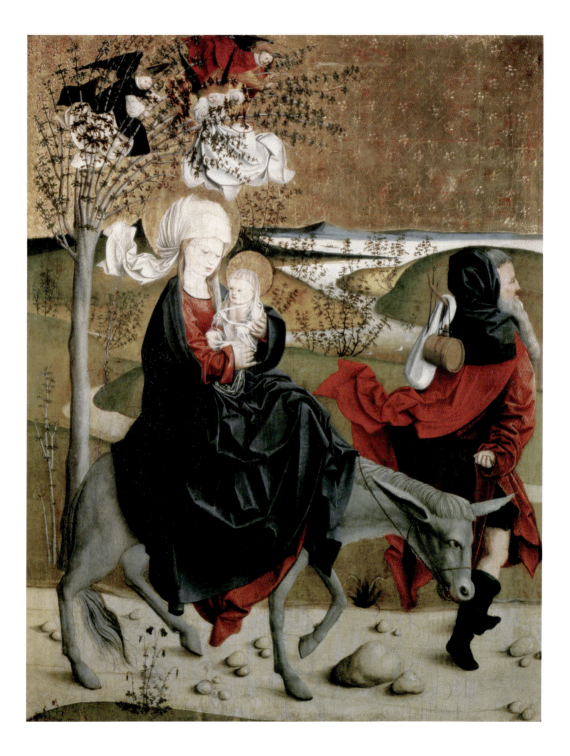

The Flight into Egypt

The Master of the Mondsee Cloister
xv century

The Flight into Egypt

Museum of the Middle Ages
Venice
Italy

Matthew concludes the episode of the Magi with the Flight into Egypt.

Shortly before Herod sent his soldiers to Bethlehem, an angel appeared to Joseph and enjoined him to flee to Egypt with Mary and the child in order to escape Herod's wrath. This sudden flight has been pictured often, the father on foot, the mother and child on a donkey.

Although the scene is often one of anguish it is also found within the tradition of European paintings described either as landscapes with figures or as figures in a landscape, depending on whether the emphasis is on the scene or on the characters. These are usually titled not *The Flight into Egypt* but *The Rest on the Flight into Egypt,* and show moments of repose and ease in lush green landscapes and, when angels bring the holy travelers food, with meals as divine as the setting is rustic.

The Narrator of the French composer Hector Berlioz's oratorio *L'Enfance du Christ* (1850) sings of the rest on the flight into Egypt thus: "The pilgrims having come to a place of fair aspect, with bushy trees and fresh water in abundance, St. Joseph said: 'Stop … .' Then Holy Mary: 'Look at this fair carpet of soft green grass and flowers that the Lord spread in the desert for my son.' Then, having sat down in the shade of three green-leaved palm trees … and the child slept, the holy travelers slumbered for a while, lulled by sweet dreams, and the angels of heaven, kneeling about them, worshipped the divine child."

The Circumcision

Luke does not recount the Adoration of the Magi, the Slaughter of the Innocents, or the Flight into Egypt, but goes directly from the appearance of the shepherds at the manger to Jerusalem and Jesus's Circumcision and the later Presentation at the Temple.

According to Jewish custom, Jesus was circumcised eight days after his birth. It was on this occasion that he was named Jesus in compliance with the angel Gabriel's instructions.

In Christian tradition, then, the circumcision figures as an equivalent of baptism and a further step toward the accomplishment of the divine plan. However, many painters have treated it realistically, presenting a ritual that to their eyes is almost exotic, imagined as performed by a high priest in a sumptuous setting.

Some of these images are often associated with the cult of relics. For centuries, the people's devotion demanded marvels, and by the late Middle Ages a trade in false relics flourished in Western Europe. In the fourteenth-century English poet Geoffrey Chaucer's *Canterbury Tales*, the Pardoner, a peddler of forged Papal pardons, also deals in fake relics. His stock of the latter, says Chaucer, includes a piece of sail from St. Peter's boat, pigs' bones, which he sells as the bones of saints, and a pillow case that he calls "Our Lady's veil." But as every age has its swindlers, the fact that at one point in time seven holy prepuces were sincerely worshipped in Western Europe is not surprising, nor does it tarnish the piety of their worshippers, some of whom made long, difficult, and costly pilgrimages to their shrines.

Michael Pacher
c. 1435–1498

The Circumcision of Christ

Parish Church
St. Wolfgang
Austria

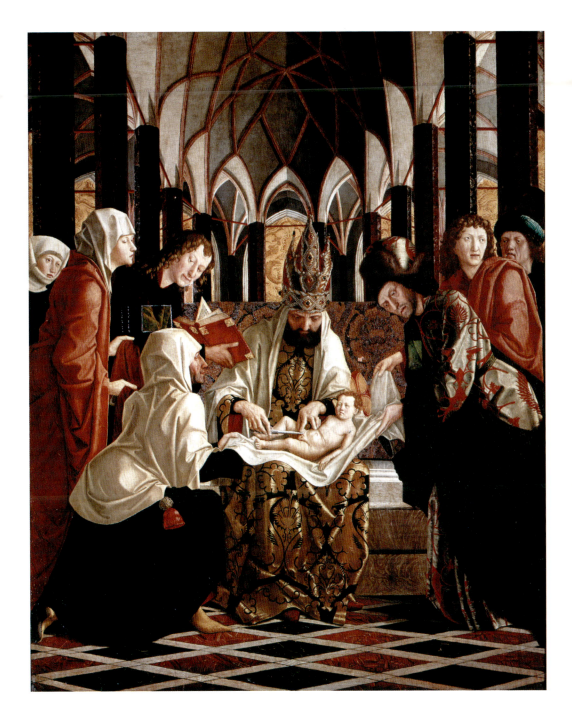

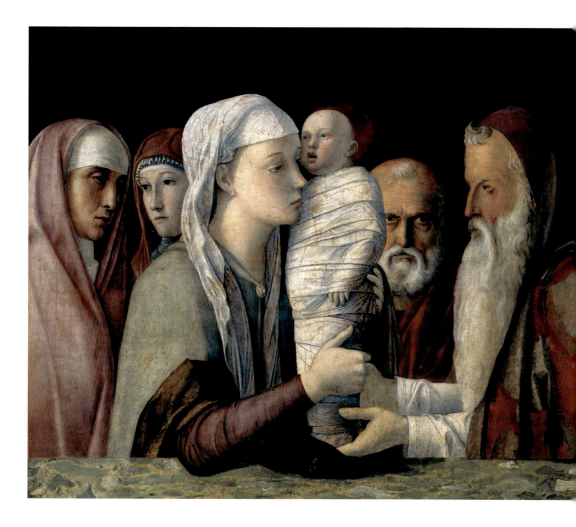

The Presentation at the Temple

Like all first-born male children born after the sacrifice of Isaac, Jesus had to be sanctified to God. Mary and Joseph went to the Temple in Jerusalem for the ceremony, which required the sacrifice of a pair of turtledoves.

Now at the Temple was an old man named Simeon (or Symon), who had been told by the Holy Spirit that he would see the Messiah before he died. When he saw Mary and Joseph with the child he instantly recognized Jesus as the Messiah, took him in his arms and offered up to the Most High the prayer known by its first two words in Latin, "*Nunc dimittis*" ("Now you are letting your servant depart in peace.")

He also told Mary of her future sufferings. "A sword will pierce your own soul too."

Moreover, standing by the Temple door, where she fasted and prayed night and day, was one Anne, a prophetess, in her eighty-fourth year. She too recognized Jesus as the Savior and began to speak about him to all those who awaited the Messiah.

Most Presentations at the Temple show the old man Simeon taking Christ in his arms, in the presence of Mary, Joseph, and the prophetess Anne. The solemn and slightly withdrawn expressions of Bellini's characters seem to reflect the specific impact of Simeon's words on each of the celebrants.

Giovanni Bellini
?1431/36–1516

Jesus at the Temple

Galleria Querini-Stampalia
Venice
Italy

Virgin and Child

Jean Fouquet
c. 1415/20–*c.* 1481

Virgin and Child

Musée des Beaux-Arts
Anvers
France

It would be difficult to list all the paintings of Mary and Jesus considered as symbols of motherhood. But whether the child is nursing or whether he is already three or four years old and reaching toward his mother, they always represent reciprocal love.

Part of the Gospels' universal appeal stems from the fact that the narrative, parables, and doctrinal passages are set in the everyday life of cities and small towns. They involve people from many walks of life and a wide range of social positions. Episodes and miracles occur during weddings, meals, and funerals, in town squares, by city gates and village wells, and involve basic human activities: eating, drinking, work, rest, traveling, conversation.

In the same spirit of humanity, painters of the Virgin and Child have added to the Evangelists' immemorial human activities the nursing of a newborn child. Although the theme involves some nudity, it is always handled delicately and chastely.

In Jean Fouquet's painting, here, the drawing and coloration distance the scene from reality and therefore preclude all but a respectful response to the event. Also, only one angel seems even to be looking toward the mother and child. The others perfunctorily assist the event or are decorative. Fouquet's handling and composition, then, acknowledge the natural aspect of the scene while directing the viewer's attention to the figures' emotions and to the spiritual significance of the moment.

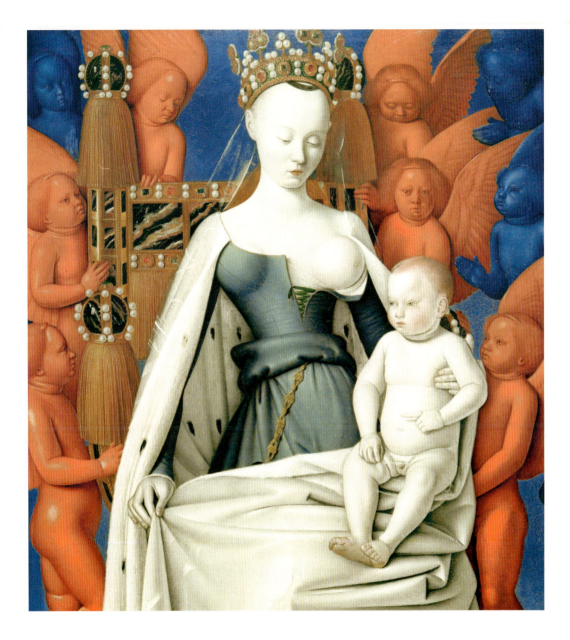

The Holy Family

The number of family members in paintings of the Holy Family varies remarkably from one work to another.

At its smallest, the Holy Family comprises Jesus, Mary, and Joseph, but such groups are quite rare. The greater number of artists add Christ's cousin St. John the Baptist, either worshipping him or playing with him. Although he is Jesus's elder, he is always shown expressing his subservience to the future Messiah. And, as in most paintings, he appears here in a child's version of the rustic clothes he was to wear as the prophet, "the voice calling in the wilderness," foretelling the coming of a greater man than himself.

The next most frequent figure is John's mother, Elizabeth, depicted as an old woman, in accordance with the Scriptures, and seen here delicately holding the slender reed staff, in the form of a cross, that is symbolic of both John's later ministry and Jesus's Passion. Less frequently depicted is her husband, St. Zachariah. Although in Matthew he is older than Elizabeth, painters depict him as younger, a near contemporary of Joseph.

Fra Bartolommeo
(Baccio della Porta)
1472–1517

The Holy Family

Palazzo Pitti
Florence
Italy

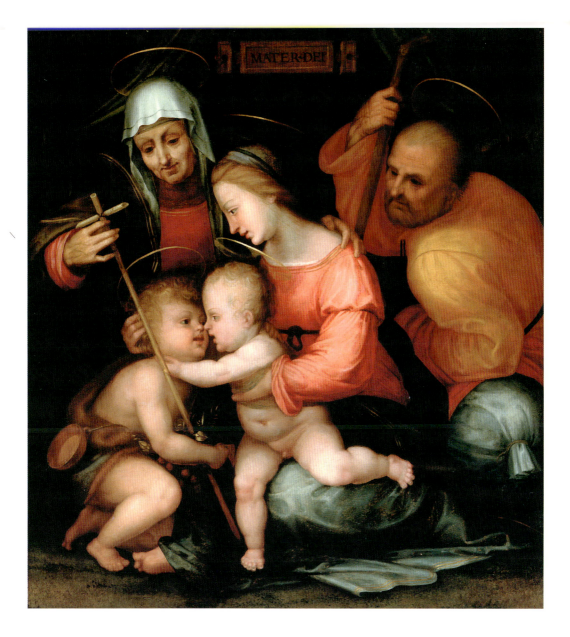

Jesus's Life in Nazareth

The Gospels do not mention Jesus's childhood. Neither does the Pharisee historian Flavius Josephus, a contemporary of the Apostles. The earliest written account of the young Jesus in Nazareth is the apocryphal fifth- or sixth-century A.D. Gospel of Thomas.

According to this text, Jesus was five years old when he performed his first miracle. Chastized by Joseph for making clay sparrows on the Sabbath, Jesus "clapped his hands together and cried out to the sparrows … 'Go!' and the sparrows took their flight and went away chirping." The text also says that he became his teacher's teacher, astonished the rabbis and scribes with his learned discourse on religious matters, and performed other miracles, including raising one of his playmates from the dead and healing a workman's shattered leg. At the age of twelve he miraculously made a wooden bed for a rich man, to the astonishment of his father, who was at the time only a carpenter of "ploughs and yokes."

Artists' imaginations have been most often engaged by Jesus as a young carpenter at his father's side. In these paintings, the workshop, carpenter's bench, stocks of lumber, and tools reflect the carpenter's trade as it was practiced in the painters' respective eras. The French poet Hérédia paraphrased the humble emotions of such pictures thus: "But in the workshop's dark recesses where the divine Apprentice is bathed in glory, golden shavings fly from the edge of his plane."

Fritz von Uhde
1848–1911
The Holy Family in the Workshop
Gemäldegalerie, Neue Meister
Dresden
Germany

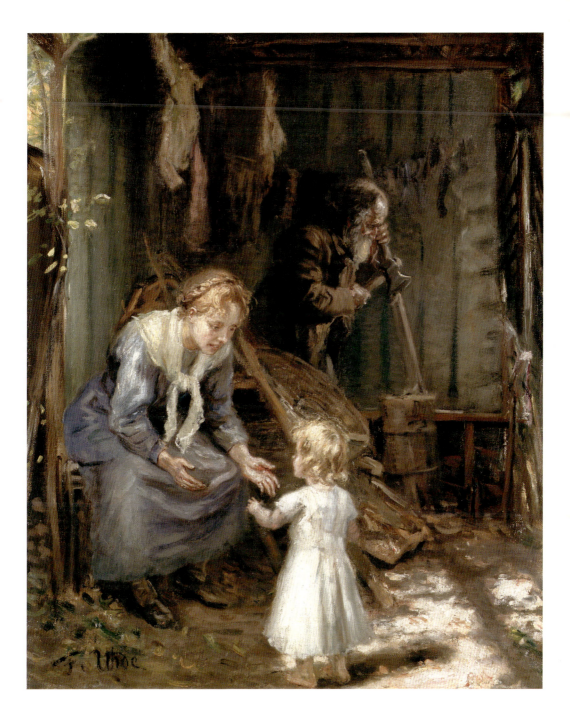

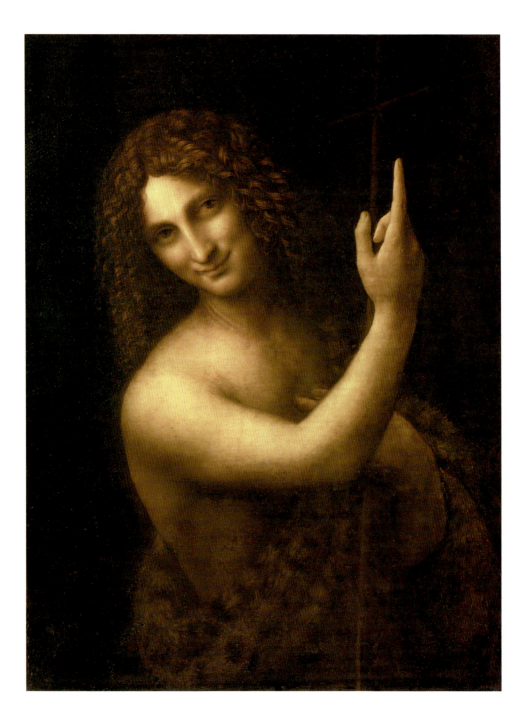

The Infant St. John the Baptist

Leonardo da Vinci
1452–1519

St. John the Baptist

Louvre
Paris

The Evangelist St. Luke said of the precursor of Christ that as a small child he withdrew to "desert places." From this comes a very old tradition of depicting him as a small shepherd dressed as he was at the time of his ministry, in a skin loincloth and cloak of camel's hair (a cloth that was, to antiquity, not luxurious but quite the opposite.) His traditional attributes are the lamb and a shepherd's crook, made of reeds, in the form of a cross.

Leonardo's painting retains these codified details. But as with the emotions of the Virgin and St. Anne in Leonardo's famous *Madonna of the Rocks*, St. John the Baptist's mood seems to come from a private region of the soul. The look he gives the viewer is clear and startling but it is also unexplainable and, therefore, ineffable. Like the *Mona Lisa*'s smile, John's smile raises unanswerable questions. Does it arise from foreknowledge of events to come? Like many things in the works of this most secretive of artists, who wrote in his notebooks with a backward, "mirror" writing, the specific source and nature of John's mood, together with its specific hold on the viewer, will probably remain a mystery forever.

Jesus and the Doctors

Albrecht Dürer

1471–1528

Jesus and the Doctors

Gemäldegalerie, Alte Meister
Dresden
Germany

When Christ was twelve his parents took him to Jerusalem to celebrate Passover, as they did every year. On the way back to Bethlehem with a great number of relatives and acquaintances, Mary and Joseph did not notice that Jesus was not among them until the evening of the first day of the journey. When they returned to Jerusalem it took them three days to find him; he had been at the Temple all the while, discussing religion with the doctors of the law, who were astonished by his knowledge and intelligence.

When Mary reprimanded him, saying, "Child, why have you treated us like this? Look, your father and I have been searching for you in great anxiety," Jesus answered, "Why were you searching for me? Did you not know that I must be in my Father's house?"

"But," adds Luke, "they didn't understand what he said to them."

Two aspects of the episode have held artists' attention. First, the mother's anguish when she realizes her son has disappeared. This is the third of the Seven Sorrows of Our Lady, the first two being Simeon's prophecy and the flight into Egypt. Yet to come are the meeting with Jesus carrying the Cross; the Crucifixion, which she watches from the foot of the Cross; the Descent from the Cross, in which she holds the body tenderly while the disciples take it down; and the entombment, where she is often accompanied by Mary Magdalene and others.

The second theme painters have expressed is the confrontation between the young Jesus and the old scribes, who are at once rapt and startled by his words.

St. John the Baptist in the Wilderness

Withdrawing at a very young age into "desert places," St. John the Baptist fed himself on locusts and wild honey. Although situated near the Jordan, whose plains are quite fertile, the image given by the Scriptures is of an inhospitable waste. However, in some seventeenth- and eighteenth-century paintings we see pleasant landscapes that anticipate those of Romanticism.

In the seventeenth and eighteenth centuries the word "desert" actually denotes not a specific climate or topography but a place of retreat. For example, after Louis xiv's annulment in 1685 of the Edict of Nantes made Protestantism illegal in France, Protestants in the south of France created the Church of the Desert. Alceste, the hero of Molière's play *The Misanthrope* (1666), after being rejected by the heroine Célimène and losing much of his wealth in a lawsuit, exiles himself to his country estate, which he terms "the desert." And the vast eighteenth-century estate of Chambourcy, near Paris—a superb landscape planted with rare species and dotted with ruins—is called the Desert of Retz.

The countryside as a theme in its own right, independent of any mythological, biblical, or historical theme, emerged in European painting only in the seventeenth century. Afterwards, the theme of St. John the Baptist in the Wilderness was often only a pretext for real or imagined landscape paintings in the styles of the painters' respective eras or according to reigning theories of the esthetics of nature.

In Thomas Cole's painting, John's wilderness is imagined by the American artist in the same pictorial terms as those of his 1830s landscapes of the Hudson River Valley, still a wilderness in his time. But Cole orientalized it with palm trees and exotic topography appropriate to the theme.

Thomas Cole
1801–1848

St. John the Baptist Preaching in the Wilderness

Wadsworth Atheneum
Hartford
USA

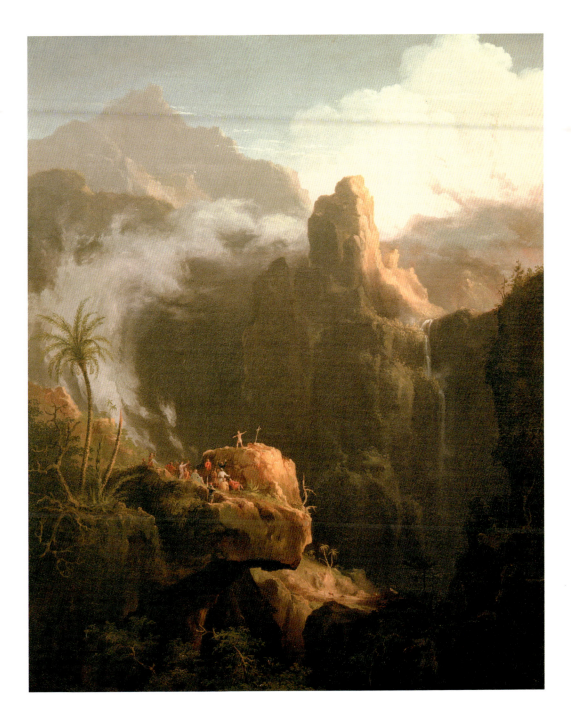

The Ministry of St. John the Baptist

St. John the Baptist came under attack because of his outspoken opposition to key aspects of orthodox Jewish dogma. Against the strict tradition recognizing sacrifices at the Temple as the only rituals for the remission of sins, he advocated the more lenient rite of baptism by immersion. This tenet is part of St. John the Baptist's larger doctrine of a last judgment, which also contradicted his era's most conservative interpreters of Hebraic law, who refused to acknowledge the possibility of resurrection.

His teachings had a great popular following, but he claimed them to be only a pale foreshadowing of what was soon to come, and called himself nothing more than "a voice crying in the wilderness." Another man would come, he said, who would baptize not with water but with the Holy Spirit, and whose shoes John himself was not worthy of tying. Hence the title often given him: the Precursor.

Paintings representing St. John the Baptist during the time of his ministry most often show him on the banks of the River Jordan surrounded by disciples. Sometimes one sees the crowds of curiosity seekers whom he called "a generation of vipers." Nicolas Poussin has given John, the new converts, and the gathered disciples aspects of the ancient Greek and Roman figures of his landscapes based on Classical myth. But in Poussin's neo-classical seventeenth century, as in all eras in which this theme was painted, the essential action is the ritual of baptism in the river.

Nicolas Poussin
1594–1665

St. John the Baptist Baptizes the People

Louvre
Paris

58

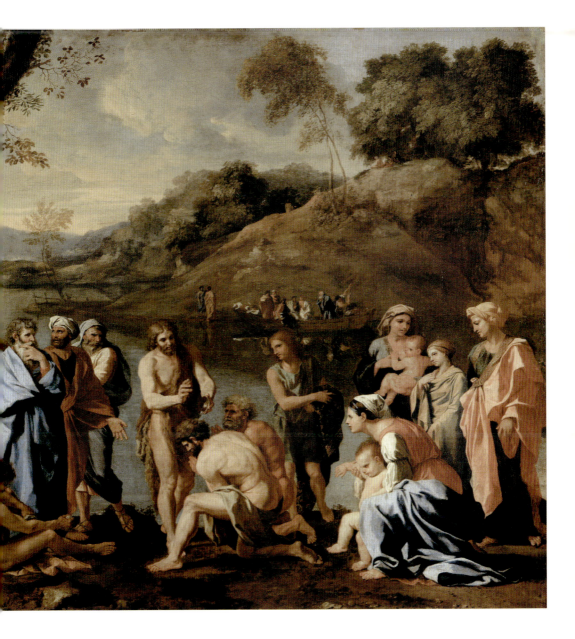

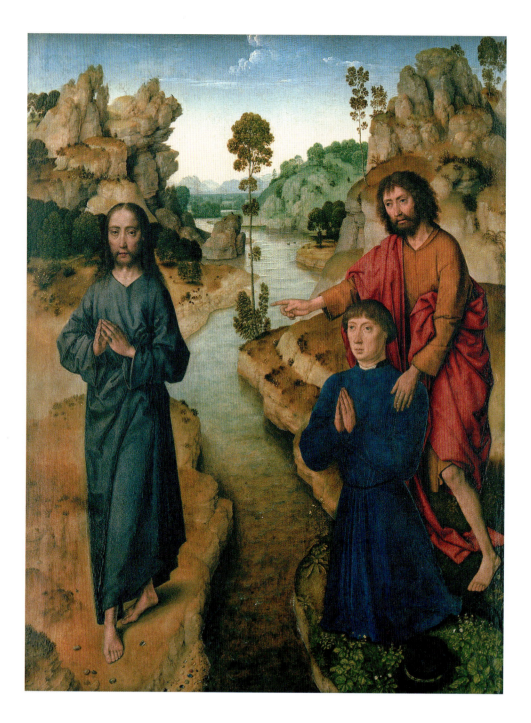

The Baptism of Jesus

Dieric Bouts

c. 1415–1475

*"Ecce Agnus Dei": Christ and
St. John the Baptist*

Alte Pinakothek
Munich
Germany

"Here is the Lamb of God who takes away the sin of the world."

With these words St. John the Baptist greeted Christ, who had come to be baptized by him on the banks of the Jordan.

John added that logically the two men's roles should be reversed, that it was rather Jesus who should baptize him. However, he obeyed Jesus and at the moment when Christ emerged from the water the heavens opened and the Spirit of God descended from them in the form of a dove while a voice proclaimed, "You are my Son, the Beloved; with whom I am well pleased."

Depictions of this founding event of Christ's own ministry almost always center around the figures of Jesus, John, and the dove of the Holy Spirit. Some painters also include John's disciples on the river bank and angels in heaven.

In Dieric Bouts's spare *Ecce Agnus Dei* there are neither disciples nor angels nor the dove, and the anonymous third figure looks very much like a man of the late fifteenth-century Netherlands as seen in many portraits of men by Bouts's Netherlandish contemporaries. He is the "donor," art history's term for the man or married couple who either commissioned a religious painting or provided the funds for it to the church that commissioned it. While the donor's presence in the painting honor his piety and his gift, and through the latter allude to his worldly success, it symbolically does something more. The presence of a donor in a scene so crucial to Christianity as the Baptism of Jesus brings the event out of the distant past into the consciousness of fifteenth-century viewers as a moment affecting their own salvation in their own times. It also allows the painting to suggest a call to meditate on the scene it represents.

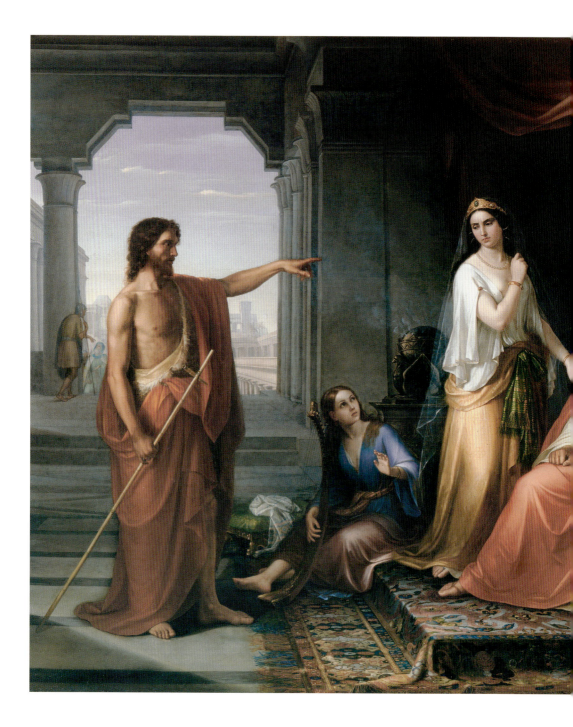

St. John the Baptist before Herod

Although John's teachings strongly displeased the most conservative members of the orthodox Jewish leadership, it was not until his outspokenness on religious matters incurred the displeasure of the political powers that his ministry proved fatal to him.

Herod Antipas, son of Herod the Great, was the reigning Jewish king under the Roman occupiers of Israel. During John's ministry he married Herodias, who was the daughter of one of his brothers and had previously been married to yet another. John denounced the marriage as incestuous according to Jewish law. "It is not lawful," he said bluntly, "for you to have her."

Luke does not give the circumstances of John's charge. However, Matthew and Mark state unambiguously that John spoke these words directly to Herod himself, and painters have followed them by presenting a dramatic confrontation between sovereign and prophet.

What is certain is that Herod had John arrested and brought before him, then imprisoned him in the fortress of Macherontis, near the Dead Sea.

This arrest did not impede the growth and development of a community of John's followers who established a pre-Christian church that was a source and, later, a rival of the church of the Apostles.

Giovanni Fattori
1825–1908

St. John the Baptist before Herod

Accademia
Florence
Italy

Salome's Dance

Salome was at once King Herod's stepdaughter and niece, for she was the daughter of his wife Herodias and her first husband, Herod's brother Philip. As Herodias was also the daughter of one of Herod's other brothers, Salome was Herod's grandniece as well.

At a banquet in honor of Herod's birthday Salome danced for him and his guests.

She danced with such grace that Herod swore to her before all the company that she could ask any reward she wished for and he would grant it, be it half his kingdom.

Matthew focuses on Salome's act, not on Salome herself, and says no more of her than that she was Herodias' "daughter" and (implying innocence) "a girl." She is a character without personality, a pawn in Herodias' persecution of John. Tradition has transformed her into a woman, a temptress with ambiguous motives. Painters have often imagined her dance as erotic. In the France of the 1870s, shaken by both the Franco-Prussian war and nineteenth-century Europe's crisis of faith, Salome paintings and statues appeared in large number, with Salome as a heroine in her own right. She has a prominent place in the décor of Charles Garnier's Paris Opera House (1875), as though her importance lay in her skill and allure as a dancer: a venomous biblical counterpart of Terpsichore, the Greek Muse of Dance. In Gustave Moreau's many Salome paintings her relationship to both John and her deed is dark. In the "decadent" 1890s, she emerges in England as the cold and cynically lascivious dancer of Aubrey Beardsley's drawings and as the heroine of Oscar Wilde's play *Salome*, in which she is in love with John and becomes Herodias' willing pawn in order to punish the Baptist for spurning her.

Franz von Stuck
1863–1928

Salome's Dance

Gemäldegalerie, Neue Meister
Dresden
Germany

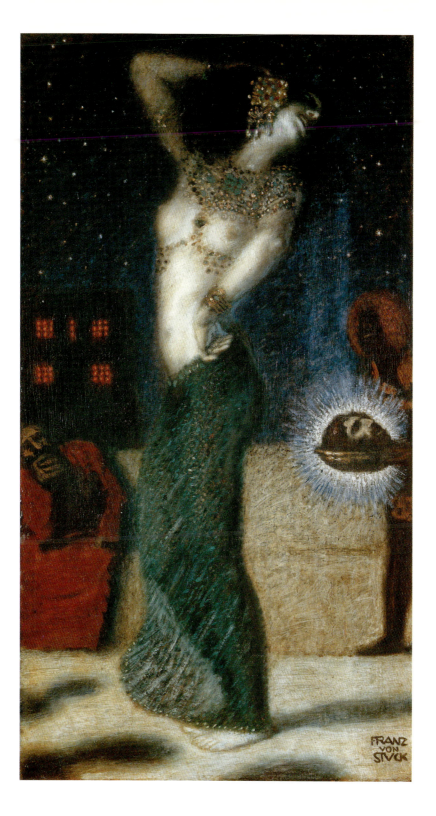

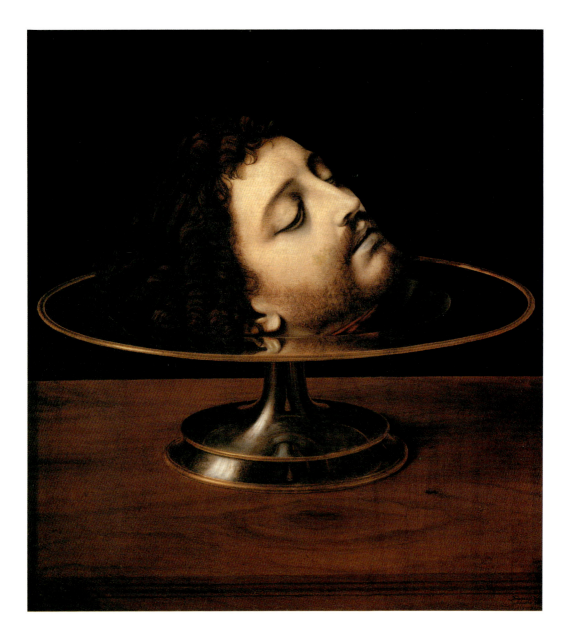

The Beheading of St. John the Baptist

Andrea Solario
c. 1465–c. 1524

St. John the Baptist's Head

Louvre
Paris

When Herod promised Salome anything she wished, the girl did not know what to ask for and ran to her mother for advice. Herodias, who had already urged her husband to imprison St. John the Baptist saw here an opportunity finally to rid herself of this irksome prophet who condemned her marriage as incestuous.

Instructed by Herodias, Salome went back to Herod and said, "Give me the head of St. John the Baptist here on a platter."

According to Mark, "Herod feared John, knowing that he was a righteous and holy man, and he protected him. When he heard him, he was greatly perplexed; and yet he liked to listen to him." Although greatly vexed by Salome's request he could not forswear himself before his guests, some of whom were powerful members of the Roman administration. He sent for a headsman to execute the prophet, whose head was then brought on a platter into the banqueting hall.

That same night John's disciples gathered his remains so carefully that today one can still worship his head in the Damascus mosque's great reliquary.

In paintings of the Old Testament stories of David and Goliath and Judith and Holofernes, the facial expressions on the severed heads of the victims are charged with pain and the anguish of defeat. But Goliath and Holofernes are the enemies of the Lord. St. John the Baptist is one of the Just. Consequently, even in the most shocking pictures of his severed head lying on the platter, his face expresses great serenity.

The Temptation in the Desert

After John baptized him, Jesus withdrew to the desert for forty days to fast and pray.

At the end of this first Lent he was hungry. Satan appeared to him and tempted him, saying, "If you are the Son of God command these stones to become loaves of bread."

Jesus replied, "One does not live by bread alone but by every word that comes from the mouth of God."

The devil then took him to the top of the Temple in Jerusalem and urged him to throw himself into the void and have the angels break his fall. Again Jesus refused.

Satan then carried Jesus to the peak of a high mountain and showed him the kingdoms of the world, saying, "All these I will give you if you will fall down and worship me."

"Away with you, Satan!" ("*Vade retro, Satana!*"), Christ shouted at him, "for it is written, You will worship the Lord your God and only him shall you serve."

Vexed, the fiend withdrew to await a better opportunity.

Whereas depictions of Jesus in paintings of this episode conform to the conventional image of the adult Christ, in paintings from the Renaissance onward painters were free to follow their respective fantasies and imaginations when painting Satan. Most of them gave him a human form embellished with such picturesque details as horns, a tail, or cloven hoofs. Thanks to other pictures and historical documents, we are sometimes able to identify Satan's face as that of an historical person whom the painter wished to subject to public calumny.

Bartholomäus Bruyn the Elder

1493–1555

The Temptation of Christ

Rheinisches Landesmuseum
Bonn
Germany

The Sermon on the Mount

Christ's teachings fully emerged with the Sermon on the Mount, spoken to his disciples as crowds were starting to run to him. In this précis of the Gospel's doctrine are found the *Beatitudes* and the Lord's Prayer as well as a number of phrases that have become proverbial: "You are the salt of the earth." "If anyone strike you on the right cheek, turn the other too." "No one can serve two masters." "Do not judge, so that you may not be judged." "Search, and you will find."

This episode has presented those painters who have treated it with a specifically difficult task: that of making a forceful painting of the essentially static situation of the standing or seated Christ speaking quietly to his disciples sitting around him on the mountainside. As the Sermon on the Mount is the key doctrinal statement of Christ's ministry, it cannot be relegated to the status of a small detail in a large, visually compelling landscape. As it addresses the understanding and the feelings in short, conceptual phrases and vivid, concrete metaphors, prettiness in the handling of the surrounding mountainside would strike the wrong note.

Fra Angelico's painting has met the challenge of this difficult theme in two ways. The clear but understated variations on the disciples' seated figures give a subtle sense of the individual effect of Christ's words on each disciple's feelings and thoughts. And the artist's vigorous and near-abstract handling of the mountainside are his visual counterparts of the content and concreteness of Christ's words. The painting is an illustration of the simplicity that it has been given to great artists like Fra Angelico to achieve.

Fra Angelico
(Fra Giovanni da Fiesole)
c. 1395/1400–1455

The Sermon on the Mount

San Marco
Florence
Italy

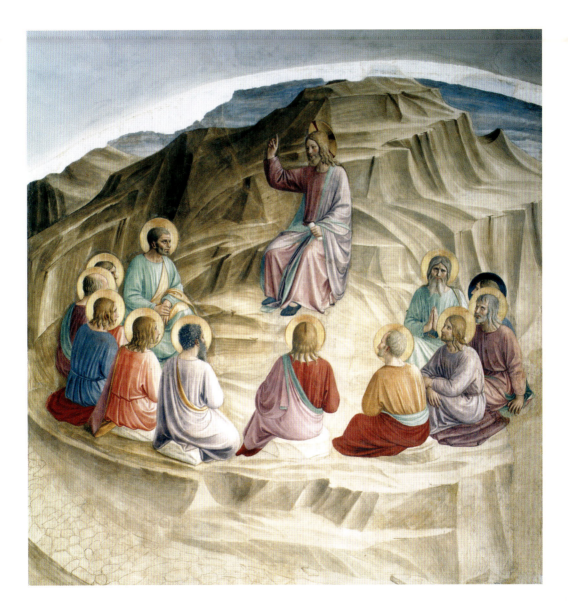

The Wedding at Cana

For his very first miracle Jesus showed a certain benevolence toward quite human failings.

Jesus and his mother attended a wedding in the city of Cana. During the feast, Mary went to Jesus and said, "They have no wine." "Woman," Jesus said, "what concern is that to you and me? My hour has not yet come."

Undaunted, Mary told the servants, "Do whatever he tells you."

There were six stone water jars of the kind used in purification rites, each with a capacity of about a hundred liters. Jesus told the servants, "Fill the jars with water."

When the jars were full to the brim, he said, "Now draw some out, and take it to the chief steward."

This man tasted and was astonished. He went to Mary and said, "Everyone serves the good wine first, and then the inferior wine after the guests have become drunk. But you have kept the good wine until now."

The best, and more than five hundred liters! We can imagine that the end of the wedding was quite joyous, at least as it appears in paintings. Nonetheless, Veronese has added a subtle dark undertone to the scene. Jesus's central position at the long table, together with the figures and gestures of the disciples on either side of him, alludes to the Last Supper. Thus, in his exuberant depiction of the very first miracle of Christ's ministry, he reminds the viewer of Jesus's tragic fate.

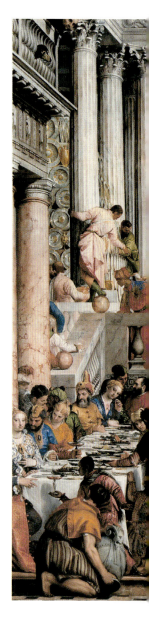

Veronese
(Paolo Veronese; Paolo Caliari)
1528–1588

The Wedding at Cana

Louvre
Paris

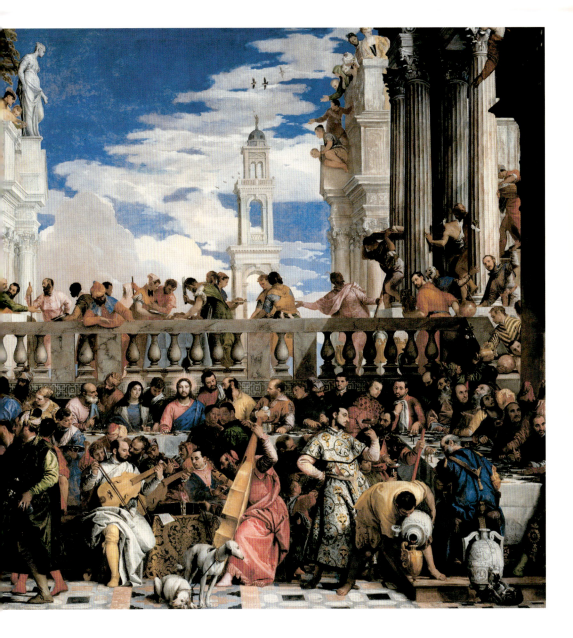

The Calling of the Apostles

Shortly after the arrest of St. John the Baptist, Jesus was staying in the city of Capernaum, north of the Sea of Tiberius, also called Lake Genesareth. It was there that he began to recruit his disciples, and, notably, the twelve who became the Apostles.

First he called fishermen at the lake, Simon and his brother Andrew, then James and his brother John, saying to them, "Come with me and I will make you fishers of men."

The choosing of the eight others remains vague, with the exception of Matthew, a fiscal agent, or publican, who collected taxes at Capernaum. To him Christ said only, "Follow me," and Matthew immediately left his tax office.

The tax inspector's trade has never been very popular in any society. To the Jews of Roman Palestine it was collaborating with the occupying forces and so publicans were shunned by the religious community. Christ's election of Matthew, then, has been construed as particularly symbolic of his mission's universality.

The names of the twelve Apostles vary from one Evangelist's to another's but tradition has reconciled them and the accepted list is as follows: Simon, called Peter; Andrew, Peter's brother; James the Great (whose mother, Salome, will appear among the sainted women entombing Christ or witnessing his empty tomb after the Resurrection); John, James's brother; Philip, who came from Bethsaide; Matthew the publican, also called Levi, author of the first Gospel; Bartholomew, born in Cana; Thomas, also called Didymus ("the twin"); James the Less, whom certain commentators have wished to make a brother of Christ; Jude, brother of James, also called Thaddeus or Lebbaeus; Simon, born in Cana and called "the zealot" (or "the Zealotite," referring to a political party perhaps contemporaneous with Christ); Judas Iscariot.

Andrea Schiavone
(Andrea Meldolla)
c. 1510–1563

The Calling of the Apostles

San Giacomo dall'Orio
Venice
Italy

74

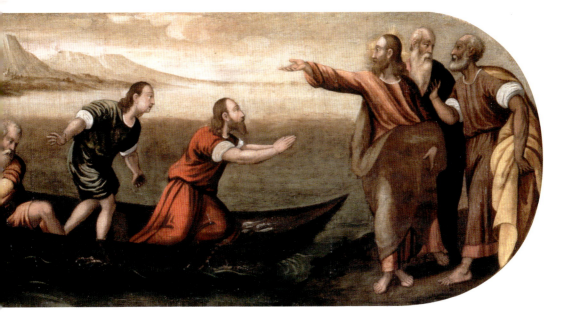

The Keys of St. Peter

One day Jesus asked his disciples what the people thought of him. The disciples replied that some of the people thought he was St. John the Baptist, others said the prophet Elijah or Jeremiah returned to earth.

"But who do you say that I am?"

"You are the Messiah, the Son of the living God," said Simon, whom Jesus had renamed Peter (from the Aramaic, *kephas*, "rock.")

Jesus said that Peter's reply had been inspired by the Holy Ghost, who spoke the words that made Peter first among the disciples. "You are Peter, and on this rock I will build my Church, and the gates of Hades will not prevail against it. I will give you the keys of the kingdom of heaven and whatever you bind on earth will be bound in heaven, and whatever you loose on earth will be loosed in heaven."

At another time Christ also told Peter, "Be thou the shepherd of my flock."

In their paintings of New Testament stories, medieval and Early Renaissance painters often referred directly to future events by placing small images of things to come in the paintings' backgrounds. In the work reproduced here we see, growing progressively more distant in proportion as the events are in the future, Mary Magdalene at Christ's feet, Christ bearing the Cross, and St. Peter's martyrdom at Rome, where he was crucified on a cross set upside down in the earth. Thus, as viewers imaginatively travel along the painting's landscape to the horizon, their imaginations also take them forward to the moment when Peter accepts the responsibility that Christ bestows upon him as he gives him the keys in the painting's foreground.

The reference to St. Peter's keys has naturally become a central motif of Catholic iconography, particularly in the periods of controversy between Catholics and Protestants.

Master of the Legend of the Holy Prior
c. 1470

Christ Handing the Keys to St. Peter

Wallraf-Richartz Museum
Cologne
Germany

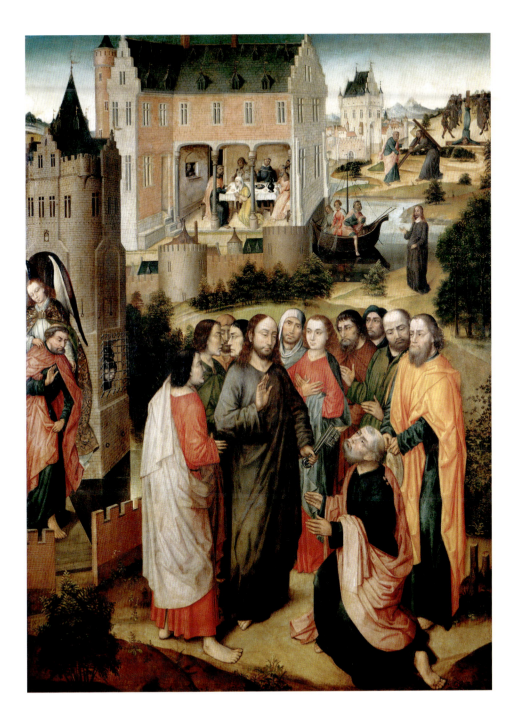

The Good Shepherd

In several conversations with his disciples Jesus likens his role to that of the shepherd, a natural image in a largely pastoral society.

The good shepherd, he explains, owns his flock and is therefore more watchful of it than a hired shepherd could be.

If he is the shepherd, his flock is the Church. "I am the good shepherd. I know my own and my own know me, just as the Father knows me and I know the Father. And I lay down my life for the sheep. I have other sheep that do not belong to this fold. I must bring them also, and they will listen to my voice. So there will be one flock, one shepherd."

Christian art's classic motif of the shepherd carrying a lamb on his shoulders derives both from these conversations and from Jesus's parable of the shepherd rejoicing over having found his lost lamb, but it also has its source in a traditional motif of Ancient Greek sculpture, known best from a statue by Calamis, a contemporary of Phidias.

In Lucas Cranach's painting, which still resides in the church for which it was painted, the presence of the donor with his large family certainly attests the donor's importance in sixteenth-century Wittenberg. But it also expresses his piety. Depicted as a successful worldly head of a large, prosperous family, the donor, by kneeling in devotion before Christ figured specifically as the Good Shepherd, implicity acknowledges himself and his family as being—in non-worldly terms—only members of Christ's vast spiritual flock

Lucas Cranach the Younger

1515–1586

The Good Shepherd

Stadtkirche
Wittenberg
Germany

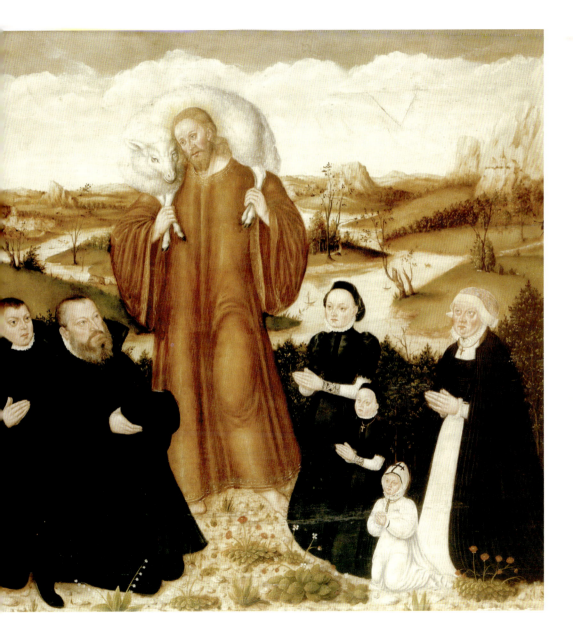

Jesus and the Woman of Samaria

Traveling from Judah to Galilee, Jesus passed through Samaria.

He halted near a spring called Jacob's Well. When a Samaritan woman came to draw water, Jesus said, "Give me a drink."

Now, as the Jews shunned the Samaritans as heretics, the woman was startled into asking Jesus how he could request such a thing from her. "If you knew," Jesus said, "who it is that is saying to you, 'Give me a drink,' you would have asked him, and he would have given you living water."

The woman immediately turned from the question of the propriety of Jesus's request to what she saw as both absurdity and pride in his statement. "Sir," she said, "you have no bucket, and the well is deep. Where do you get that living water? Are you greater than our ancestor Jacob, who gave us the well?"

"Everyone who drinks of this water will be thirsty again, but those who drink of the water that I will give them will never be thirsty," Jesus replied. "The water that I will give them will become in them a spring of water gushing up to eternal life."

The woman realized that it was no longer a matter of well water, and that the need was hers and not Jesus's, and asked him for the living water.

"Go, call your husband and come back," Christ said. When she said that she didn't have a husband he praised her answer. "You have had five husbands, and the one you have now is not your husband."

The woman realized she was speaking with a prophet and began a long theological discussion, during which Jesus uttered the famous phrase, "Salvation is from the Jews," and said he was the Messiah.

Annibale Carracci

1560–1609

Christ and the Samaritan Woman by the Well

Kunsthistorisches Museum
Vienna

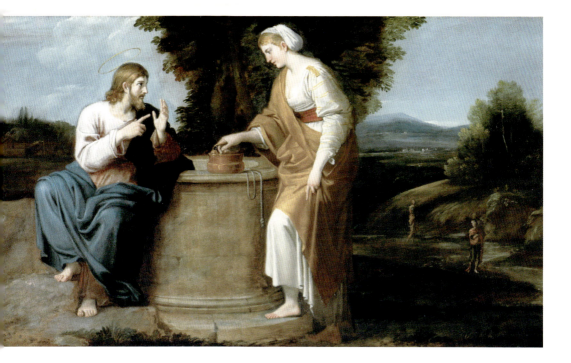

The Preaching at Genesareth

Christ's ministry was at first narrowly confined to the shores of Lake Genesareth (also called the Sea of Tiberius after Herod founded the city of Tiberius on its shore in A.D. 17). His teaching was immediately successful there and his first disciples came from cities along the lake: Tiberius, Magdala, Genesareth, Capernaum, and Bethsaide, and from Naim, Cana, Gadar, and Nazareth, a short distance from it.

Drawn by his words and miracles, people in ever-increasing numbers came to hear him, not only from these regions but also from Jerusalem, from across the Jordan, and from Tyre and Sidon, fifty and seventy-five miles north of Genesareth respectively.

The Preaching at Genesareth, with its tiers of crowds on the bank, the port, and the fishing boats, with Christ preaching from one of them, contains enough picturesque elements for many painters to have been inspired by them.

Grigori Grigorievitch Tchernyshov
1801–1865

The Sermon at the Sea of Tiberius

Russian Museum
St. Petersburg
Russia

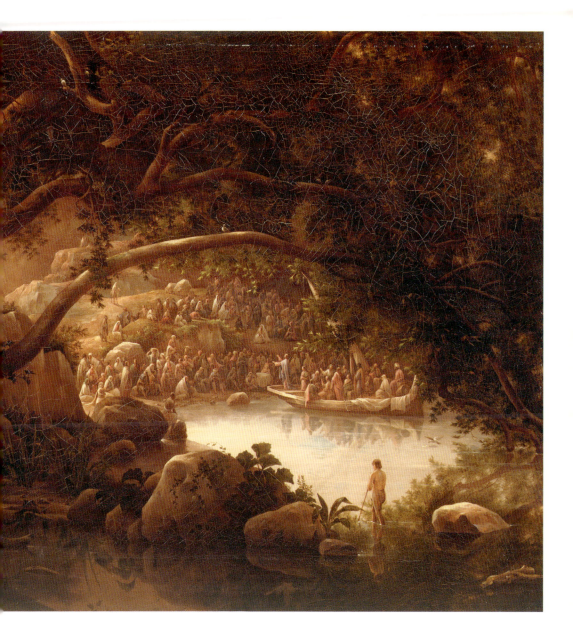

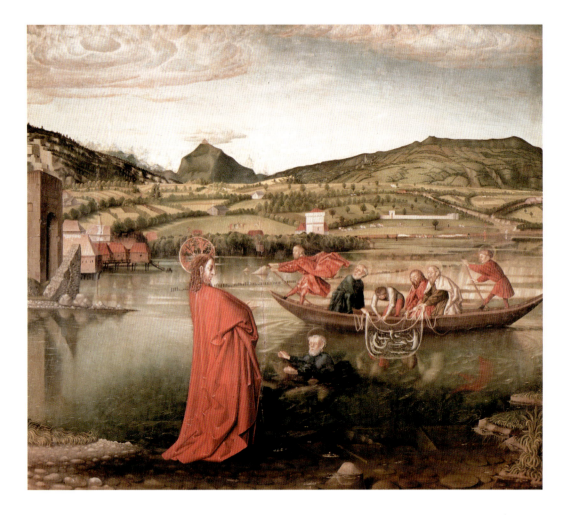

The Miraculous Draught of Fishes

Konrad Witz
c. 1400/10–*c.* 1445/46

*The Miraculous Draught
of Fishes*

Musée d'Art et d'Histoire
Geneva
Switzerland

The Sea of Tiberius, two hundred eight meters above sea level, forty-five meters deep, and fed by the mountain snows of Lebanon, is the region's largest fresh-water reserve. It is still quite full of fish and a species of perch named for St. Peter is still caught there.

Jesus was preaching from Peter's boat to a large number of people on the shore. When he finished he told Peter, "Put out into the deep water, and let down your nets for a catch."

"Master," Peter said, "we have worked all night long but have caught nothing. Yet if you say so, I will let down the nets." And he caught so many fish with the first cast that his nets were full to the bursting. The crew asked another boat to help. But the net was so heavy that both boats began to sink.

An almost terror-stricken Peter fell to his knees at Christ's feet and said, "Go away from me, Lord, for I am a sinful man."

Luke places this miracle at the beginning of Christ's ministry. But John places it after the Resurrection, when Jesus appears to his disciples by the Sea of Tiberius, and says that Jesus broiled and ate some of the miraculous catch to show that he had returned from the dead in his full physical being. And so some discrepancies among the Gospels reveal either the Evangelists' different understandings of Jesus's acts and sayings, or the singular literary or theological use an Evangelist makes of them.

The story's unfailing success explains how this episode has inspired painters for centuries on end.

In Konrad Witz's painting, Jesus is on the shore and Peter has jumped from the boat and is wading toward him. Thus Peter's chagrin and his outburst, a matter of words in Luke, are communicated visually through the image of Peter, waist-high in the water, struggling and gesturing toward his awaiting Lord

Jesus Walking on the Water

In depicting this miracle some painters have conflated two Gospel episodes that tell of Jesus calming a storm on the Sea of Tiberius.

In the first, he does not walk on the water. He asks his disciples to take him to the opposite shore of the lake so that he might get away for a while from a crowd that has gathered to hear him. When they are far from shore a great wind rises and huge waves strike the boat, threatening to sink it. Jesus, however, sleeps peacefully. The disciples wake him, crying, "Master, Master, we are perishing!"

"Where is your faith?" he replies, and with a gesture quiets the winds and sea.

In the second story, he asks his disciples to wait for him on the far shore, then stays a while in a withdrawn spot. Again, a storm comes up and again the disciples take fright, rowing desperately into the headwinds. In utter darkness, they see Christ walking on the water. At first they think it's a ghost but he reassures them.

In a fit of rapture, St. Peter jumps onto the water and begins to walk to meet Jesus, but sinks little by little. "Lord, save me!" he cries. Christ immediately takes him by the hand, saying, "You of little faith, why did you doubt?"

They regain the boat and, with a gesture, Christ causes the wind to fall.

Philipp Otto Runge

1777–1810

Christ Walking on the Water

Kunsthalle
Hamburg
Germany

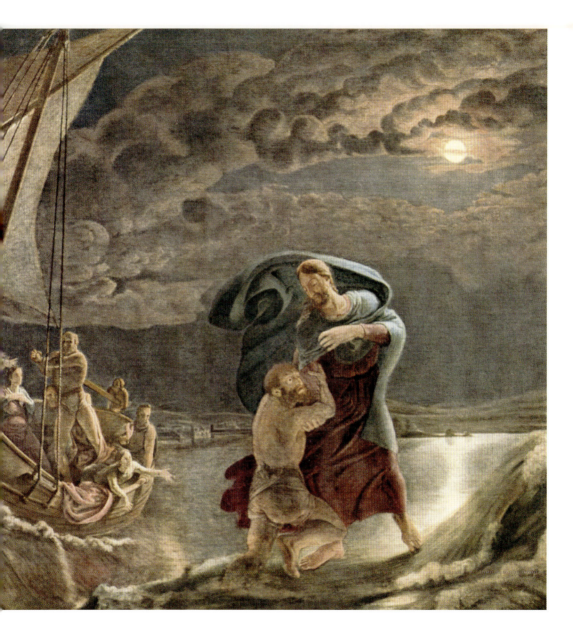

Mary Magdalene at Christ's Feet

Mary Magdalene is so named because she came from Magdala on the shore of the Sea of Tiberius. According to the Scriptures, Jesus rid her of seven devils. She is not to be confused with Mary, sister of Martha and Lazarus, who came from Bethany, near Jerusalem, and who, a few days before the Passion, anointed the Lord's feet with perfume before wiping them with her hair.

However, tradition and iconography make one person of the two Marys and conflate her with yet another woman, the anonymous sinner who washes Christ's feet with perfume and dries them with her hair.

When Jesus was dining with other guests at the home of Simon the Pharisee a woman whom Matthew, Mark, and John call simply "a woman," and Luke "a woman … who was a sinner," but whom tradition has termed a prostitute, came uninvited into the hall, threw herself at Jesus's feet, covered them with her tears, anointed them with perfume from an alabaster jar, and wiped them with her hair. The Pharisees at Simon's table were scandalized that Jesus had let "a sinner" approach him thus.

Jesus told them, "Her sins, which were many, are forgiven: hence she has shown great love." Tintoretto's painting expresses Mary Magdalene's repentance in the small, simple, but affecting gesture of her hand modestly pressing the neckline of her bodice against her chest.

Paintings of this episode have various titles, including "The Banquet at Simon's House …" and "The Magdalene at the Pharisee's House [or at Simon the Leper's House] …," almost always ending in "… at Bethany," thus attesting the confusion among the three Marys. Painters have this excuse: in 1521, after long debate, the Sorbonne declared that there had been only one Magdalene.

Tintoretto
(Jacopo Tintoretto)
1519–1594

The Banquet in the House of Simon

Museo Civico
Padua
Italy

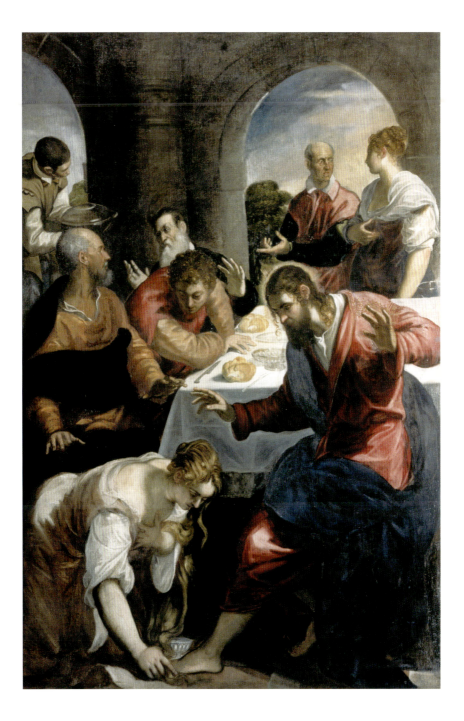

Martha and Mary

On his way to Jerusalem Jesus stopped at the house of Lazarus and his sisters Martha and Mary in Bethany. In order to receive the Lord appropriately, Martha busied herself in the kitchen but Mary sat at Christ's feet and listened to his words.

Annoyed, Martha interrupted, speaking familiarly to Jesus. "Lord, do you not care that my sister has left me to do all the work by myself? Tell her then to help me."

But Christ chastised her, not her sister. "Martha, Martha," he said, "you are worried and distracted by many things: there is need of only one thing. Mary has chosen the better part, which will not be taken away from her."

This was an almost brusque way to affirm the absolute superiority of the kingdom of God over all the contingencies of this world, legitimate or honorable though they be. For a number of artists, however, it was the occasion for celebrating these contingencies in the form of household tasks and women's work, which are easier to render than Mary's mute adoration. In the painting reproduced here, Velázquez honors women's work by endowing the objects of it with exceptional beauty, from the heavy mortar and pestle down to the smallest piece of fragile garlic skin. Also, his allegiance to the reality of the human condition here is such that with Martha's emotion he acknowledges the common human resentment at unwanted chores. With the image of the older woman, her hand on Martha's shoulder, Velázquez also evokes our frequent need for counsel from those more experienced, more patient, and more forgiving than ourselves.

Diego Velázquez
1599–1660

Christ in the House of Martha and Mary

The National Gallery
London

The Raising of Lazarus

"Lord, already there is a stench." This remark of Martha, the dead man's sister, underscores the spectacular aspect of Christ's raising Lazarus from the dead. There was already a stench because Lazarus had been buried for four days.

When Lazarus fell sick in Bethany, Christ's teachings had begun to elicit violent opposition. Many Jews openly advocated stoning him to death, and at one point a crowd gathered around him almost did. To give passions a chance to cool, Jesus withdrew to the east bank of the Jordan. It was there that a message from Martha and Mary apprised him of their brother's illness.

However, it was only when he heard of his friend's death two days later that he told his disciples he would cross the river and re-enter Judah. The disciples, knowing the region still dangerous to him, were astonished and afraid.

Mary and Martha were in their house with many people who had come to comfort them when they learned that Jesus was approaching Bethany. Martha left and met him outside the gates. He tried her faith by saying Lazarus would rise from the dead, and found it steadfast. Martha went home and secretly told Mary what had happened. Mary left abruptly and went to Jesus and wept. The comforters arrived and wondered aloud if Jesus could revive Lazarus as he had healed the blind.

Jesus went to the stone grotto outside of town that served as Lazarus's tomb. It was when he asked that it be opened that Martha cried out about the stench.

Approaching the now open tomb, Jesus shouted, "Lazarus, come out." Immediately the dead man stepped into the light, wrapped hand and foot in narrow cloths and his face covered with sweat.

"Unbind him and let him go," Christ said.

Juan de Flandes
c. 1465–1519

The Raising of Lazarus

Prado
Madrid

The Healing of the Cripple

This title is given to paintings of two different miracles performed by Jesus under dissimilar circumstances, each of which resulted in religious controversy.

When Jesus was preaching in a house in Capernaum, the dense crowd inside and out kept a cripple from approaching him. His friends went up onto the roof, removed some tiles, and lowered him into the house by ropes attached to his palette. At the sight of the man's faith Jesus said, "Your sins are forgiven you."

Some doctors of the law present were outraged: by what right, they asked, did Jesus forgive sins?

"Which is easier to say," Christ asked them, "'Thy sins are forgiven you,' or 'Stand up and walk?'"

To make his point clear he turned to the cripple and said, "Stand up and take your bed and go to your home."

The miracle put an end to the scribes' quibbling.

At another time, Jesus was at the gate of Jerusalem near a pool called the Well of Bethesda. Many sick people could always be seen there, for at certain times the angel of the Lord would stir the waters and the first person to immerse himself in them afterwards was healed. Among the crowd that Jesus saw was a cripple who for thirty-eight years of continuous trying had been kept by his lameness from being the first in the water. To him also Jesus said, "Stand up, take your bed and walk."

This time the doctors of the law were indignant because the miracle occurred on the Sabbath.

When the title does not specify which miracle a painting represents, the picture itself often tells us. The tall columns and vast portico in the background of Tiepolo's painting place the scene at the Well of Bethesda. When a painting shows the interior of a simple house and, sometimes, the man being lowered into it from the roof, we know we are seeing the miracle of Capernaum.

Giovanni Domenico Tiepolo
1727–1804

The Miracle at Bethesda

Louvre
Paris

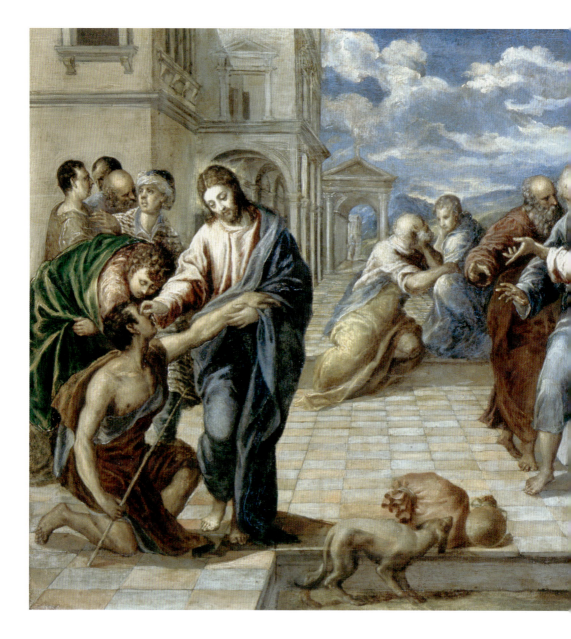

The Blind Man of Jericho

The Gospels' accounts of this miracle differ as to how many blind men Jesus healed. But as it is the miracle that matters, the story is the same whether it involves one blind man, or two, or more.

According to Matthew, as Jesus was leaving Jericho two blind men sitting by the city gates heard that it was Jesus who was passing out of the city and cried to him, "Lord, have mercy on us, Son of David!"

The crowd wanted Jesus to silence them but they kept imploring him. He asked them what they wanted. "Lord, let our eyes be opened!" they replied. "Go," Jesus said, "your faith has made you well."

Paintings always show three protagonists, Jesus, the blind men, and the crowd.

With the middle ground's image of a young fair-haired disciple keeling before a seated, imploring older man, who is either just healed or still to be brought before Christ, El Greco follows Matthew. He also follows a detail not in Matthew but in Luke, who mentions a "large crowd." And it is, in effect, El Greco's crowd, its intense faces, gestures, and angular, animated figures, and its three figure groups echoing, intensifying, and adding to each other's emotions, that express the event's intrinsic nature, at once astonishing and miraculous.

El Greco
(Domenikos Theotokopoulos)
1541–1614

Christ Healing the Blind

Gemäldegalerie, Alte Meister
Dresden
Germany

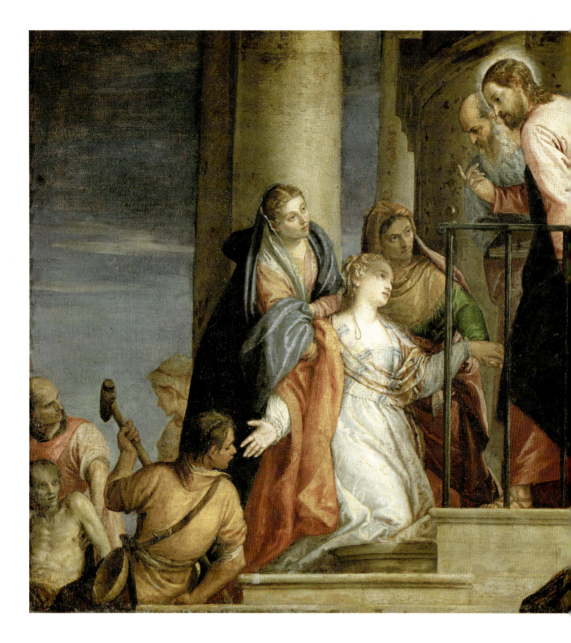

The Resurrection of the Widow's Son at Naim

Naim, or Nain, is a small town south of Nazareth. Accompanied by a crowd of disciples and curiosity seekers, Jesus was about to enter it when a funeral procession came out of the city on its the way to the burial of a widow's son.

As the two processions passed each other Jesus pitied the mother and both groups stopped.

Jesus told the mother, "Do not weep," and walked over to the open coffin. "Young man," he cried, "I say to you, rise!"

The dead man sat up and Jesus gave him to his mother.

By placing a lame man with his crutch in the painting's lower foreground—a detail not in the Gospels—Veronese alludes to many more miracles than the healing of the widow's son. Thus he expands the painting's reach not with respect to time but with respect to parallel events within the overall time frame of Christ's ministry. By a poetic logic specific to the art of painting, then, all the miracles of Christ's ministry occur simultaneously in an imagined world with laws of time and space that are not those of the world of the Gospels' narrative or of the real worlds of the painters, their first audiences, and ourselves.

As two different crowds of people witnessed this miracle the news of it quickly spread from Galilee all the way to Judah.

Veronese
(Paolo Veronese; Paolo Caliari)
1528–1588

The Widow of Naim

Kunsthistorisches Museum
Vienna

Jesus Heals a Centurion's Slave at Capernaum

The complex social situation of Palestine under Roman rule during the time of Jesus is reflected by the personality of the centurion of Capernaum. He was an officer of the occupying army but was mindful of his slaves' well-being; he was a pagan but had paid for the building of a synagogue out of his own funds. Also, in Roman society slaves frequently rose to high positions of responsibility and trust in their masters' households.

When Christ entered Capernaum the centurion's slave was close to death. Knowing that a Jew could not enter an idolater's house, the Roman sent some Jewish friends to ask him to come to heal his slave. The Jews commended him warmly to Jesus as being so sympathetic to the faith of Israel that he had financed the construction of a house of worship.

As Jesus approached the house, the centurion threw himself at his feet, saying "Lord … I am not worthy to have you come under my roof … . But only speak the word, and let my servant be healed."

Moved with admiration, Jesus said to his disciples, "Truly I tell you, in no one in Israel have I found such faith. I tell you, many will come from east and west and will eat with Abraham, Isaac, and Jacob in the kingdom of heaven, while the heirs of the kingdom will be thrown into the outer darkness, where there will be weeping and gnashing of teeth." And the slave was healed.

In short, he proclaimed the possible salvation for Gentiles and the possible damnation of Jews. This is a basic text for Christianity that artists of military Europe were obliged to illustrate, especially because in it grace is accorded to a soldier.

Giovanni Domenico Tiepolo
1727–1804

The Centurion of Capernaum

Kunsthalle
Bremen
Germany

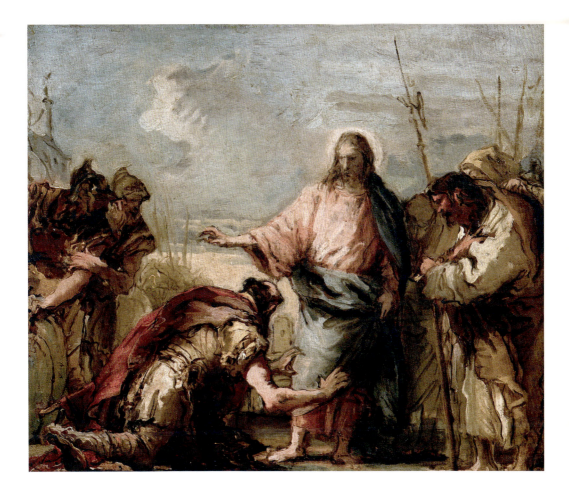

The Daughter of the Canaanite

Jesus preached not only in the Holy Land but also on the east bank of the River Jordan, and even in the Phoenician coastal cities of Tyre and Sidon, far to the north of Jerusalem. His reputation preceded him everywhere.

When Jesus was in Tyre, a Canaanite woman heard of his presence in the city, sought him out, and begged him to exorcise a demon who was tormenting her little girl.

At first Christ told her, "I was sent only to the lost sheep of the house of Israel."

As she insisted he became harsh, saying, "It is not fair to take the children's food and throw it to the dogs."

"Yes, Lord," she said, "yet even the dogs eat the crumbs that fall from their masters' tables."

"Woman," Jesus said, "great is your faith. Let it be done for you as you wish." And the demon went out of her daughter.

Ludovico Carracci's Christ appears to be turning and speaking in mid-stride. Thus simply by the drawing of a figure and gesture, Carracci has expressed the effect on Christ of the Canaanite woman's startlingly blunt challenge. Carracci has, in effect, given visual expression not to the miracle of the story but to Matthew's and Mark's powerful narrative art. To artists, then, the painting is equally a painter's homage to Christ and to earlier artists in another medium. To the faithful, it stands as testimony to the Holy Spirit's inspiration of the Evangelists during the composition of their immortal accounts of their Lord on earth.

Ludovico Carracci
1555–1619

Christ and the Canaanite Woman

Brera
Milan
Italy

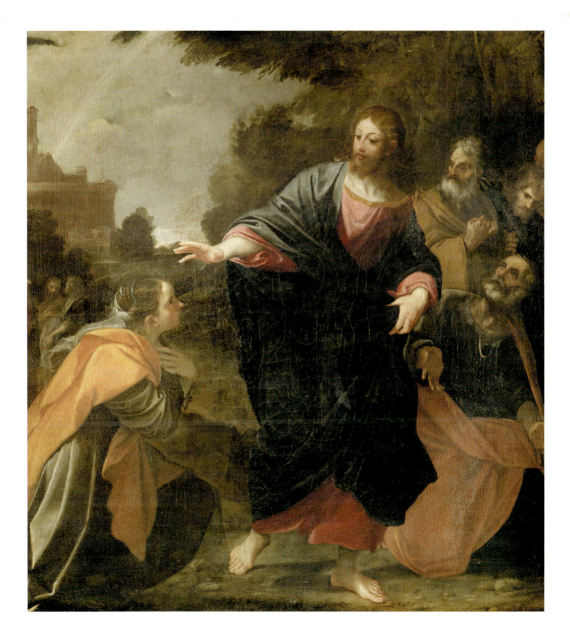

The Resurrection of Jairus's Daughter

Jairus was the chief rabbi of the synagogue of Capernaum. As his twelve-year-old daughter was dying he went to entreat Christ, who was returning from the eastern shore of the Sea of Tiberius. Jesus set out with Jairus, but on the way Jairus's servants met them with the news that the girl was dead.

When they arrived at the house they found it full of the tumult that, in Jewish society at the time, accompanied mourning. "Why do you make a commotion and weep?" Jesus asked. "The child is not dead but sleeping."

Despite the incredulity of those present he went into the death room with the father, the mother, and those who were accompanying them. There he spoke to the dead child in her own language, Aramaic, "*Talitha koum*" ("Little girl, get up.") Immediately she stood up.

Although it has not enjoyed the popularity of the Raising of Lazarus, this miracle of the daughter of Jairus has provided material for touching scenes at the dead girl's bedside. The child playing with the dog in the foreground of Santi di Tito's painting of the miracle alludes to the joyful world of childhood that Jairus's young daughter lost when she died but which, now that she is restored to life, she will soon enjoy again. Equally enhancing the vision of innocent happiness to come are the figures of the cherubs and, on the carved bedpost, the image of a young girl, gently smiling.

Santi di Tito
1536–1602

The Resurrection of Jairus's Daughter

Kunsthistorisches Museum
Vienna

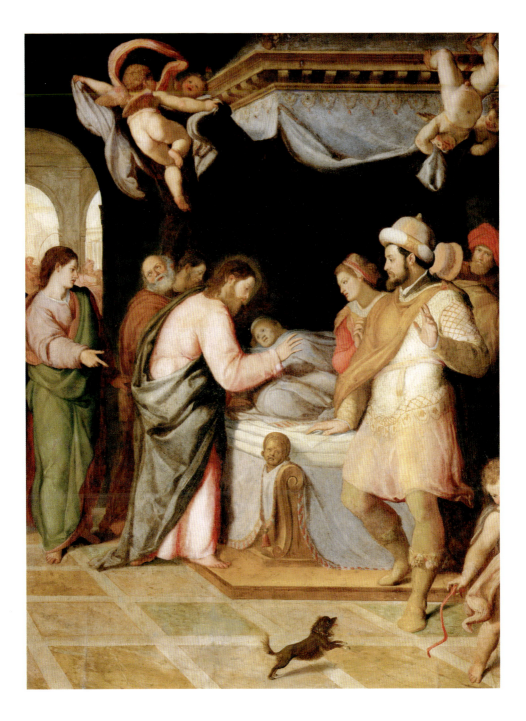

The Multiplication of the Loaves and Fishes

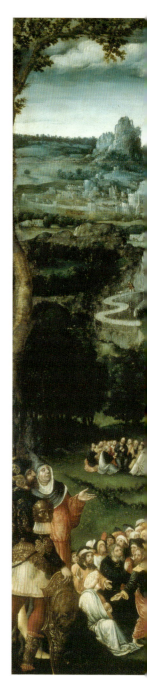

This miracle occurred just after the death of St. John the Baptist.

When he learned of John's death, Jesus took a boat out onto the Sea of Tiberius in order to find a deserted spot to pray in on the opposite shore. But the crowds who were following him guessed where he was going and when he stepped off the boat it was only to find an enormous assembly.

Moved by compassion for them, he preached and healed as they had hoped he would.

As evening gathered, his disciples advised him to send the crowd off to find supper in the surrounding towns. "They need not go away; you give them something to eat," he replied.

The disciples found nothing but the five loaves of bread and two fishes that they had brought themselves.

Jesus told the people to sit in groups of one hundred, then blessed the loaves, broke them in pieces, and gave them to his disciples, who handed them out themselves.

Everyone ate his fill and the leftovers filled twelve baskets. The five loaves and two fishes fed four to five thousand men, as well as women and children.

This miracle has so much struck the imagination that the multiplication of the loaves of bread has given rise to a multiplication of stories; one counts no fewer than six versions of it in the four Gospels. Small wonder, then, the profusion of paintings.

Joachim Patinir
c. 1480–c. 1524

The Multiplication of the Loaves of Bread

Escorial
Madrid

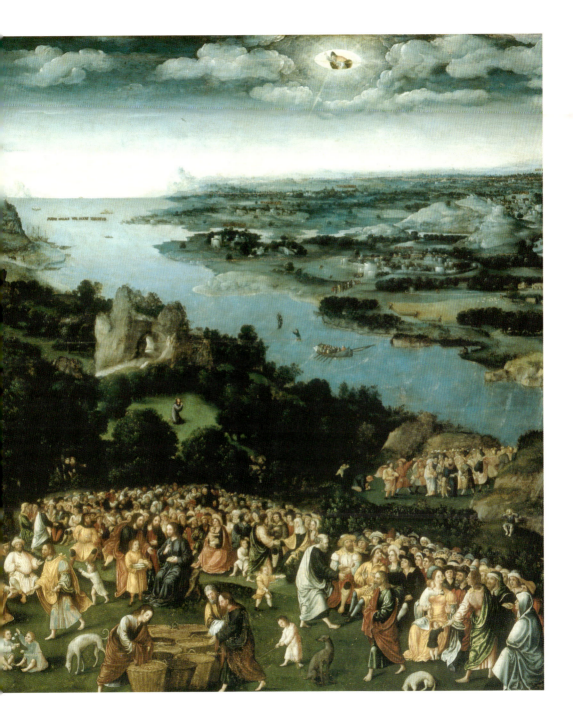

The Transfiguration

This essential episode in the life of Jesus is told in almost the same way by Mark, Luke, and Matthew.

One day Jesus took Peter, James, and John up a mountain with him (Mount Thabor, according to later tradition). Suddenly his appearance changed in front of their eyes. His face shone, his clothes were bright, and he was conversing with the prophets Moses and Elijah.

Then a bright cloud overshadowed them and out of it came a voice, saying, "This is my Son, the Beloved; with him I am well pleased: listen to him." The terrified disciples fell with their faces to the ground until Christ raised them up.

As they were coming down the mountain, Jesus made them promise to "Tell no one about the vision until after the Son of Man has been raised from the dead."

He continued equally enigmatically. "Elijah has already come, and they did not recognize him, but they did to him whatever they pleased. So also the Son of Man is about to suffer at their hands." The disciples understood that he was speaking of St. John the Baptist.

In addition to confirming Christ's divinity, the episode alludes to St. John the Baptist's martyrdom and to the fate awaiting Jesus himself. This explains the importance accorded to it by Christian theology.

Gerard David
c. 1460–1523

The Transfiguration

Notre Dame
Brussels

The Woman Taken in Adultery

When Christ was teaching in the Temple in Jerusalem, the Pharisees and the doctors of the law brought a woman taken in the very act of adultery before him and put him to a test to see if his teachings' practical consequences complied with the law.

According to Mosaic law, adultery was punishable by stoning. "Now what do you say?" they asked him. Jesus sat scribbling with his finger on the floor, showing no interest whatsoever in the affair. When his interlocutors pressed him he raised his eyes for a moment and said, "Let anyone among you who is without sin be the first to throw a stone at her," and went back to writing in the dust.

The Jews began to withdraw, the eldest departing first. When he was alone with the woman, Jesus asked her, "Has no one condemned you?"

"No one, sir."

"Neither do I condemn you. Go your way, and from now on do not sin again."

Paintings of certain biblical themes like Susanna and the Elders, and, here, the woman taken in adultery, require the image of a nude, semi-nude, or immodestly dressed female figure. And Lorenzo Lotto, faithful to the text, has not denied the woman's bare shoulders and hastily covered body. But with the painting's concentration on so many vividly emotional faces and strong gestures surrounding the compassionate, mild Christ, he has deflected much of the viewer's attention from the story's heroine to the Gospel narrative's main point: the dispute over the woman's case and Christ's response to it.

Lorenzo Lotto

c. 1480–1556

Christ and the Woman Taken in Adultery

Louvre
Paris

Suffer the Little Ones to Come unto Me

One day the disciples "spoke sternly" to people who were bringing their children for Jesus to touch and bless.

"Let the little children come unto me," Jesus said, "and do not stop them; for it is to such as these that the kingdom of heaven belongs." On another such occasion he added, "Truly I tell you, whoever does not receive the kingdom of God as a little child will never enter it."

We also think of children when Jesus said, "Truly I tell you, just as you did it to one of the least of these … you did it unto me."

The depiction of Jesus surrounded by a joyous band of children has become a classic theme of Christian iconography.

Master HB of the Griffon Head
c. 1550

Christ Blessing the Children

Louvre
Paris

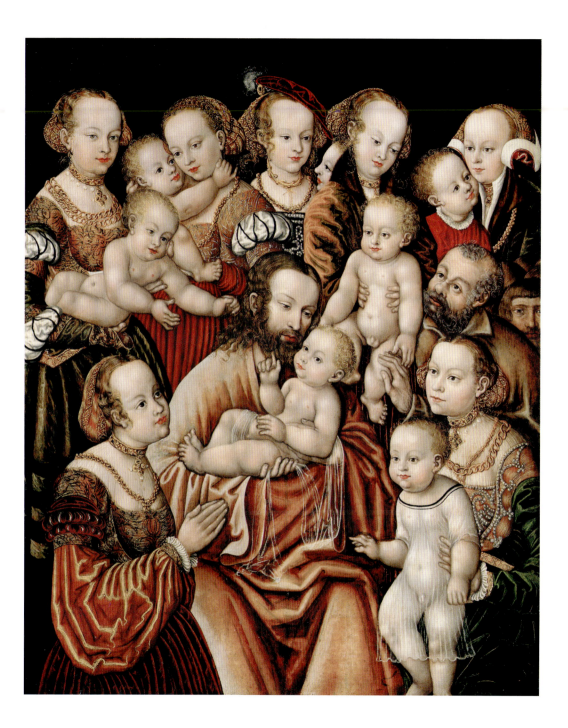

The Parable of the Good Samaritan

A Jew traveling from Jerusalem to Jericho was attacked by thieves, who covered him with blows, stripped him of his garments, and left him for dead on the side of the road. A priest passed by but turned his eyes and quickened his step, as did a Levite.

Next came a Samaritan, a member of a community despised by the Jews. He tended to the wounded man, set him on his donkey, and led him to an inn. The next day he gave the innkeeper money for the wounded man's expenses and said that on his return journey he would reimburse him for any additional costs.

Christ told this parable to enlighten a doctor of the law with respect to the meaning of the word "neighbor." The commandment "Love thy neighbor as thyself" does not apply solely to those close to us.

This dramatic but optimistic scene focusing on the Samaritan and the wounded man enables artists to honor human solidarity through large foreground images of the Samaritan's act of pity. In small background details of the painting reproduced here, Bassano brings the story's three earlier episodes (the brutal robbery, and the priest and the Levite turning their backs on the victim) into the painting's present moment. The friendliness between the dog and the donkey—two different species allegorical of the Jews' and the Samaritans' mutually exclusive communities—underscores the story's major theme.

Francesco Bassano the Younger
1549–1592

The Good Samaritan

Kunsthistorisches Museum
Vienna

The Parable of the Bad Steward

Reviewing his accounts one day, a king noticed that one of his slaves in a high position at court owed him a thousand talents. Unable to pay, the man fell to his knees before his master. "Have patience with me and I will pay you everything," he begged.

The king could have sold the man and his family at the slave market but he was moved and made him a gift of the debt.

Now as the man was leaving the palace he met a fellow slave who owed him a hundred pence. Seizing him by the throat and almost choking him, he demanded his money. The other asked him to be patient but the pitiless slave had him thrown into prison until he received repayment.

The indignant king said to the man, "Should you not have had mercy on your fellow slave, as I had mercy on you?" And he turned him over to be tortured pending complete repayment of the thousand talents he had just given him as a gift.

The king is obviously God, who pardons but who also understands that man, in turn, must pardon his neighbor.

Jesus told his parable in response to Peter's question, "Lord, if another member of the church sins against me, how often should I forgive? As many as seven times?"

"Not seven times," Christ answered him, "but, I tell you, seventy-seven times."

Several moments of this parable appear in paintings, including the bad slave's begging for mercy, his strangling (literally or figuratively) his fellow servant, and the king's indignation.

Domenico Fetti
c. 1589–1624

The Unmerciful Servant

Gemäldegalerie, Alte Meister
Dresden
Germany

The Parable of the Prodigal Son

Impatient to discover the world, the younger son of a family asked his father for his share of the inheritance. His father agreed and divided the family fortune between his two sons.

The youth immediately set out for distant lands, where he quickly squandered his fortune in debauchery. After he was ruined a famine came and he had no alternative but to become a swineherd, a supreme abomination in Palestine at the time of Jesus, when the pig was the uncleanest of unclean animals.

Dying of hunger, he decided to return to his father's roof.

As soon as his father spied him along the road he rushed to embrace him and the penitent son told him, "I have sinned against heaven and before you; I am no longer worthy to be called your son."

But the father was beside himself with joy. He organized an impromptu feast and ordered the fatted calf to be killed. The elder brother was vexed by this but his father replied, "But we had to celebrate and rejoice, because this brother of yours was dead and has come to life; he was lost and has been found."

The parable illustrates Christ's saying, "There will be more joy in heaven over one sinner who repents than over ninety-nine righteous persons who need no repentance." Jesus aimed it at the Pharisees, represented by the older brother.

Artists have been inspired by the moving episode of the reunion under the elder brother's cold gaze. But others painted scenes of the prodigal son squandering his fortune with prostitutes.

Rembrandt
(Rembrandt van Rijn)
1606–1669

The Return of the Prodigal Son

Hermitage
St. Petersburg
Russia

The Parable of the Bad Rich Man

There was once a rich man who was always splendidly dressed and who kept his house in a perpetual state of revelry. He paid scant attention to poor Lazarus, who nursed his sores under his porch and who would have gladly appeased his hunger with the rich man's crumbs.

Both died. From the depths of hell, where he moaned in flames, the rich man saw Lazarus sitting with Abraham in heaven. "Father Abraham," he cried, "have mercy on me and send Lazarus to dip the tip of his finger in water and cool my tongue."

Abraham answered that the abyss separating heaven and hell was impassable.

"Then … I beg you," the rich man cried, "to send him to my father's house—for I have five brothers—that he may warn them, so that they will not also come into this place of torment."

"They have Moses and the prophets," Abraham replied, "they should listen to them."

"If someone goes to them from the dead, they will repent."

But Abraham was inflexible. "If they do not listen to Moses and the prophets, neither will they be convinced even if someone rises from the dead."

The beginning of the story, with its violent contrast between rich and poor, has greatly inspired artists.

Joseph Danhauser
1805–1845

The Rich Spendthrift

Österreichische Barockmuseum
Vienna

The Parable of the Blind Leading the Blind

It's hard to imagine a shorter text that has inspired so many painters. Jesus said only, "If one blind person guides another, both will fall into a pit."

But Pieter Bruegel the Elder's dramatic painting based on it, imagining a pitiable procession of six blind men—a work faithfully copied by Bruegel the Younger—has inspired subsequent artists, poets as well as painters, to embellish the same theme. Directly inspired by Bruegel, the nineteenth-century French poet Baudelaire envisioned the strange procession thus:

"With their tenebrous orbs flickering this way and that at who knows what, they go like sleepwalkers and are singular, and horrible."

Pieter Bruegel the Elder

c. 1525/30–1569

The Parable of the Blind

Museo e Gallerie Nazionali di Capodimonte
Naples
Italy

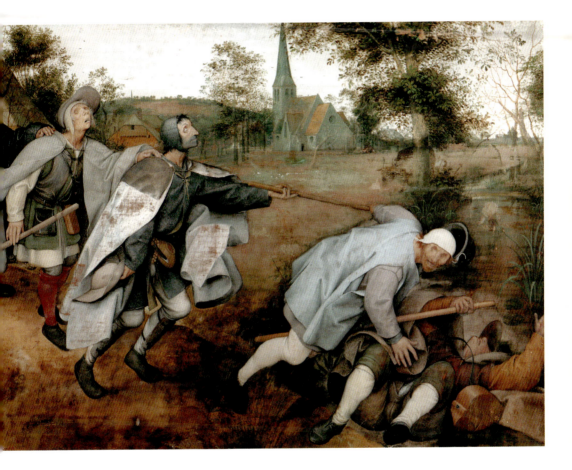

Plucking Grain on the Sabbath

One Sabbath day late in his ministry in Galilee, as controversy about his teachings was becoming widespread and vociferous, Jesus and his disciples were walking in the fields. The disciples became hungry, and as it was harvest time they began to gather heads of wheat to nibble at. To some Pharisees who chanced to observe them this was work, and as work of any kind was forbidden on the Sabbath they spoke out against it. Jesus asked them if they had forgotten David, who to feed himself and his followers "entered the house of God and ate the bread of the Presence," or if they'd never read the law according to which "priests in the Temple break the Sabbath and yet are guiltless."

"The Sabbath was made for humankind," he added, "and not humankind for the Sabbath." And alluding to himself, he said, "The Son of Man is lord of the Sabbath."

After this confrontation Christ began to increase his infractions of strict sabbatarian observance, most dramatically by healing the sick in public. When Pharisees in the crowds voiced their outrage he replied to some with the simple statement that the important thing is to do good, even on the Sabbath; to others he argued that as they themselves did not scruple to rescue one of their sheep that had fallen into a well on the Sabbath, it followed that it was permissible to save a man's life on that day.

As doctrinal controversy does not lend itself to pictorial representation, painters have dealt with this episode as a walk in harvest fields, and sometimes as an allegory of summer. Quite often, the background's farmhouses, towns, and rural people appear as they did in the painter's time. These details firmly set the biblical scene in the midst of everyday life and are expressed in visual terms referring directly to the experience of the painting's original audience. They, consequently, can feel the holy scene as a familiar one.

Martin van Valckenborch
1535–1612
The Parable of the Sabbath
Kunsthistorisches Museum
Vienna

The Parable of the Wise and Foolish Virgins

On the eve of a wedding, the ten maids of honor go with lamps to welcome the bridegroom. Five of theme are prudent and take extra oil with them; the others are flighty and make no such provision.

But the bridegroom is delayed and the maidens fall asleep. In the middle of the night there is a great stir: the bridegroom is coming. As the young women refill their lamps the foolish virgins ask the wise ones to give them a little oil. "No!" say the wise ones. "There will not be enough for you and for us; you had better go to the dealers and buy some for yourselves."

When they return, the wedding party has gone inside and the bridegroom has shut the doors. The foolish virgins rap at the gates but the bridegroom replies from within, "Truly, I tell you, I do not know you."

Christ's conclusion has become proverbial. "Keep awake therefore, for you know neither the day nor the hour"—of your death or of the end of the world.

Diaz de la Peña has imagined the foolish virgins in terms of a conventional female figure of early nineteenth-century Spanish paintings: well-to-do, over-dressed, frivolous, vain, and conceited. Thus he has expressed the maidens' imprudence in terms of his own culture, and given his sense of the social status of a family that has ten bridesmaids for their daughter's wedding.

Narcisse Diaz de la Peña
1807–1876

The Foolish Virgins

Louvre
Paris

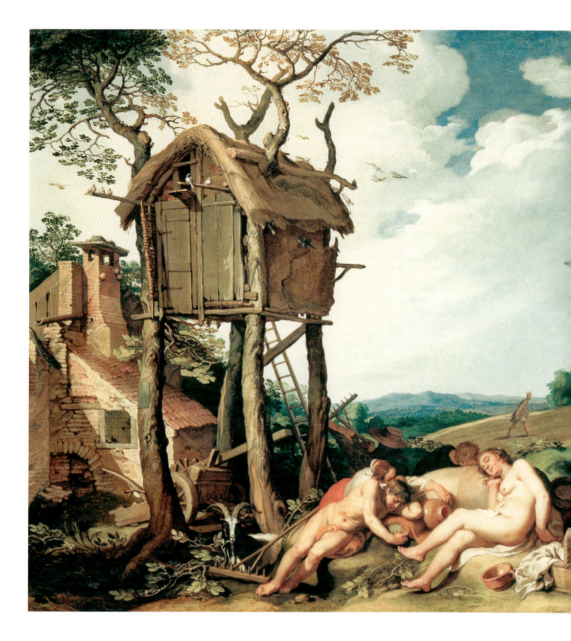

The Parable of the Weeds among the Wheat

A landowner sent his slaves out to sow his fields with wheat. When they sat down to rest and had fallen asleep, the landowner's enemy came and sowed "tares" (weeds) among the wheat seeds. When the plants began to sprout, the slaves offered to pluck the weeds out one by one, but their master said, "No; for in gathering the weeds you would uproot the wheat along with them. Let them grow together until the harvest."

Jesus wanted to give a complete explication of this parable. "The enemy … is the devil; the harvest is the end of the age, and the reapers are angels." As for the seeds, these are men, the good mixed in with the bad.

In general, painters have used this parable as a basis for pastoral scenes, set at the time of sowing rather than of reaping. In the pastoral scene shown here, Abraham Bloemart has followed two of his era's dominant conventions: that of setting a biblical scene in the audience's own times and locale, and that which required pastoral paintings to allude to antiquity by the use of Classical poses and the half-clothed or undraped human form. Bloemart knew what all artists know: that if one wishes to convey a deeper message concerning the meaning of a particular theme, including a spiritual one as well known to seventeenth-century audiences as a theme from the New Testament, the painting must sometimes address the viewer in a visual language that is familiar to him.

Abraham Bloemaert
1566–1651

The Parable of the Sower

Walters Art Gallery
Baltimore
USA

The Parable of the Workers at the Eleventh Hour

Early one morning a landowner went out to the marketplace and hired day laborers for his vineyard at the usual daily wage.

He returned to the marketplace around "the third hour" (about nine o'clock) and hired others to whom he said only, "I will pay you whatever is right." He went back at the sixth hour, at the ninth (noon and three o'clock), and once again at the eleventh (a little before nightfall), hiring additional hands each time.

When the day was over he gave each man the standard payment of one denarius. The men who had worked all day began grumbling. "These last worked only one hour, and you have made them equal to us who have borne the burden of the day and the scorching heat." The landowner replied to one of them, "Friend, I am doing you no wrong; did you not agree with me for the usual daily wage?"

Jesus concluded, "So the last will be first, and the first will be last. For many are called but few are chosen."

The scene of the hiring is the most frequently depicted.

Domenico Fetti
1588/89–1623

The Workers at the Eleventh Hour

Gemäldegalerie, Alte Meister
Dresden
Germany

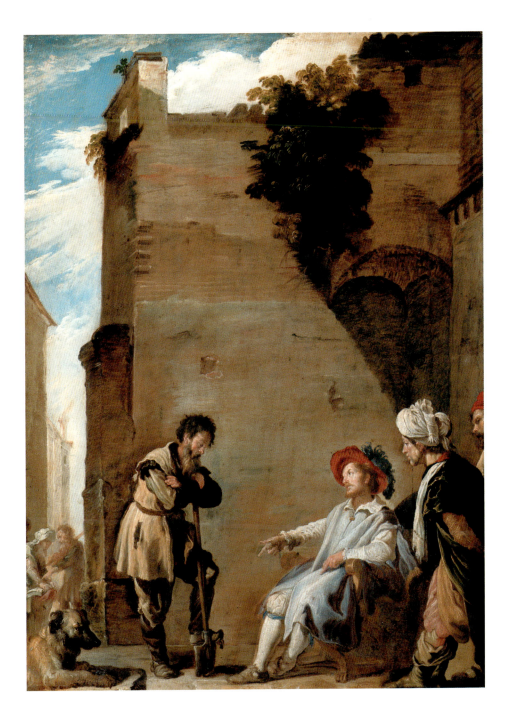

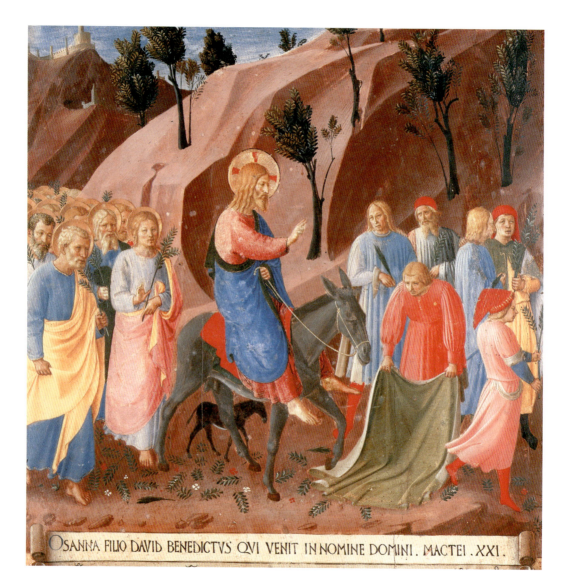

OSANNA FILIO DAVID BENEDICTVS QVI VENIT IN NOMINE DOMINI. MACTEI. XXI.

Christ's Entry into Jerusalem

Fra Angelico
(Fra Giovanni da Fiesole)
c. 1395/1400–1455

Christ's Entry into Jerusalem

San Marco
Florence
Italy

As Passover was approaching, Jesus set out for Jerusalem. He paused at Bethany, a short distance from the Holy City, and sent his disciples to a nearby village, there to fetch him an unridden donkey they would see tied to a tree, her colt at her side.

To the animal's astonished owners the disciples spoke just as Jesus had told them to, "The Lord needs them," and led the animals away.

Riding to Jerusalem thus seated on a donkey's foal, Jesus embodied a Messianic vision in the verses of the prophet Zachariah:

Rejoice greatly, O daughter Zion!
Shout aloud, O daughter Jerusalem! Lo!
Your king comes to you: triumphant and victorious is he,
humble and riding on a donkey, on a colt, the foal of a donkey.

As he went on toward Jerusalem the people strewed the way with leafy branches cut from roadside palm and olive trees and some spread their cloaks across the road.

Pharisees in the crowd were outraged that one could welcome him as the Messiah. "Teacher," they shouted, "order your disciples to stop!"

"I tell you," he replied, "if these were silent, the stones would shout out."

Palm Sunday's jubilant spectacle, ushering in the week of tragedy, has inspired innumerable compositions, pious, vigorous, or enthusiastic, and all the great classic museums provide several interpretations of it.

The Cleansing of the Temple

All four Evangelists recount this scene of Christ's rage.

Once in Jerusalem, Jesus went straight to the Temple, where he found its square filled with stalls of merchants selling sacrificial bulls, lambs, and doves, and of money-changers who dealt with Jews of the Diaspora arriving in Jerusalem with foreign coin.

"Take these things out of here!" he shouted in his rage. "It is written, 'My house shall be called a house of prayer'; but you are making it a den of robbers."

He grabbed some ropes, twisted them into a whip, and lashed the merchants and their livestock with it, chased the merchants and their livestock out of the square, overturned their stalls, and dashed the money-changers' coins to the ground.

This is the only incident of Christ's anger to have inspired strongly dynamic compositions. In his handling of the merchants' faces, Rembrandt has given free rein to his own characteristic and deeply felt sense of our common humanity. Here, as in so many of his paintings, he sees the human body not only as a form but as an expression of a human sensibility, a face not only as an identity but as a subjectivity, and he penetrates to the private person and his fragilities beneath the public person and his mask. Thus the viewer's sympathies are drawn not only to Christ but also to the men who have caused the indignation that at once moves them to fear and drives the painting's intense composition.

Rembrandt
(Rembrandt van Rijn)
1606–1669

*Christ Driving the
Money-changers from
the Temple*

Pushkin Museum of Fine Arts
Moscow

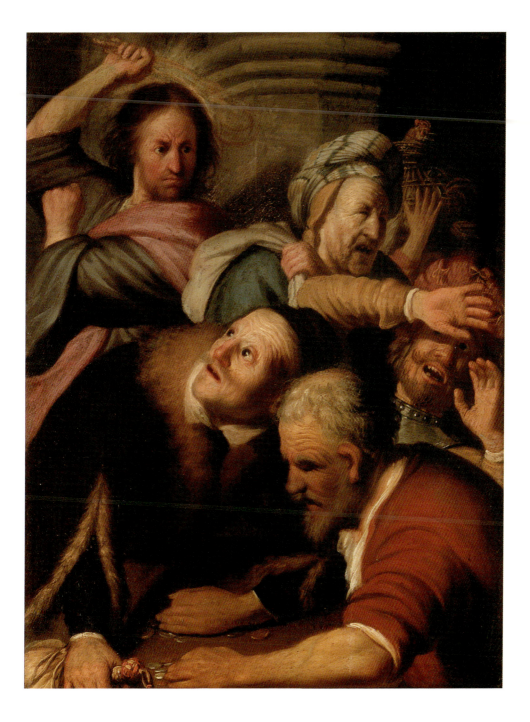

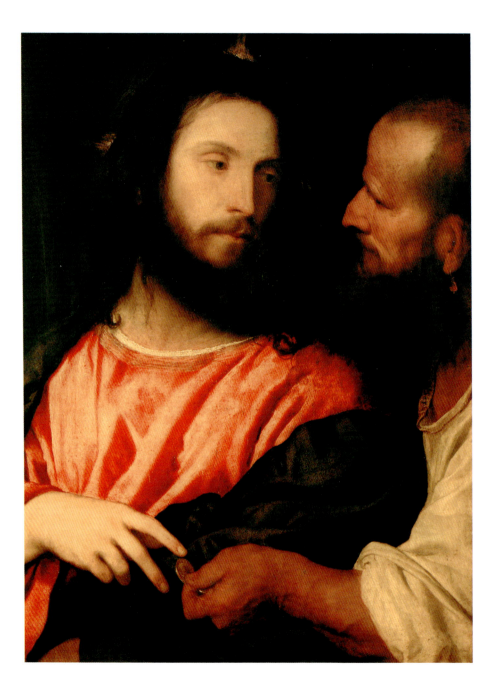

Rendering unto Caesar what is Caesar's

Titian
(Tiziano Vecellio)
c. 1485/90–1576

The Tribute Money

Gemäldegalerie, Alte Meister
Dresden
Germany

The famous question, "Is it lawful to pay taxes to the emperor?" wasn't a disinterested one. The Pharisees who asked it feigned humility and a simple wish for enlightenment but were in fact trying to trick Jesus into giving damning evidence against himself no matter which way he answered. To the Jews, paying taxes to Rome was the religious offense of collaborating with the occupying power; to the Palestinian Roman administration, not paying them was the capital crime of treason.

"Why are you putting me to the test, you hypocrites?" Jesus said. "Show me the coin used for the tax."

They gave him a denarius minted by the Romans.

"Whose head is this?" Jesus asked, "and whose title?"

"The emperor's," they answered.

Upon which Jesus uttered the famous sentence, "Give therefore to the emperor the things that are the emperor's, and to God the things that are God's."

This episode is the origin of the fundamental distinction between the spiritual and the temporal, which was to become one of Christianity's great innovations.

Titian's painting illustrates one of the many ways painters of biblical themes appeal to the imagination, thus involving the viewer intimately with the scene. Capturing the passing of the coin from the Pharisee to Christ in mid-gesture, Titian imaginatively projects the moment forward to Christ's impending statement, known to all. But with the brotherly looks exchanged by the two men, Christ's tinged with compassion, the Pharisee's with simple curiosity, the "Hypocrites!" of Christ's first, angry response seems a thing of the past. The Gospels do not recount the parting between Christ and his questioners. The painting enables the viewer to imagine it as gentle, and thus imaginatively unite the angry Christ of some Gospel episodes with the compassionate Jesus of the Gospels generally.

The Washing of the Feet

Knowing that his hour was at hand, Jesus shared Passover with his disciples. A sympathizer lent his upper room, where the disciples prepared the traditional meal.

During supper, Christ "got up from the table, took off his outer robe, and tied a towel around himself. Then he poured water into a basin and began to wash the disciples' feet."

In this era, when people walked barefoot or in sandals, washing someone's feet was part of the code of hospitality. It was ordinarily relegated to servants and slaves, so for a free man to do it was a source of humiliation.

When Jesus began to wash their feet the disciples were shocked.

Peter was incredulous. "Lord, are you going to wash my feet?" And when Jesus said yes, Peter categorically refused. "You will never wash my feet." But when Christ replied that his refusal would mark a permanent breach between them, Peter relented. "Lord, not my feet only but also my hands and my head!"

Part of the Maundy Thursday liturgy and practiced by all priests from the Pope to the parish priest, the washing of the feet ritual complies with Jesus's injunction, "I have set you an example, that you also should do as I have done to you."

Artists have been drawn to the dramatic and emotionally complex moment of Peter's hesitation, with Christ kneeling at his feet.

Pseudo-Boccaccino
(Giovanni Agostino da Lodi, attributed to)
c. 1500

The Washing of the Apostles' Feet

Accademia
Venice
Italy

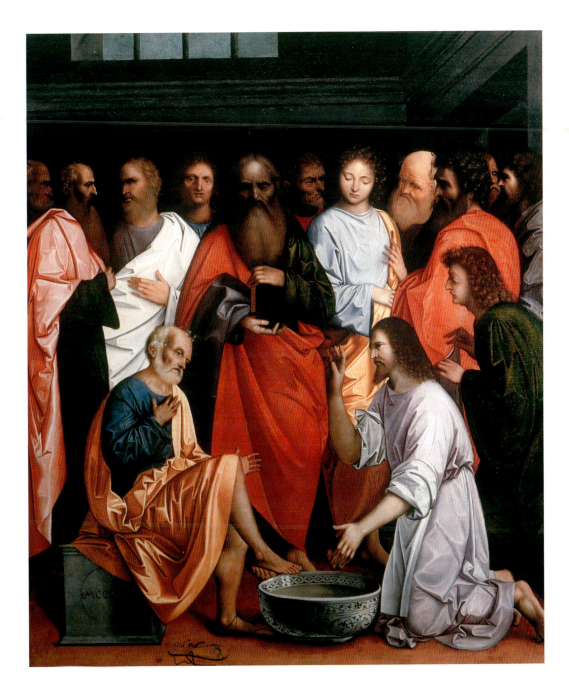

The Last Supper

Christ's last Passover, traditionally called the Last Supper, is rich in dramatic moments, most notably Jesus's announcement that he will be betrayed by one of his own, and the moment of the disciples' suspicion of one another.

Dieric Bouts
c. 1415–1475

The Last Supper

Église St. Pierre
Leuven/Louvain
Belgium

With his head on Jesus's breast, the beloved disciple John asks who the traitor could be. According to John, Christ says, "It is the one to whom I give this piece of bread," and, dipping it in his dish according to the Passover ritual, hands it to Judas, saying, "Do quickly what you are going to do." Judas then leaves.

In all four Gospels, when this episode is concluded Christ takes some bread, blesses it, breaks it into small pieces, and distributes them to the Apostles, saying, "Take, eat, this is my body." Then he takes a cup of wine, blesses it and passes it around, saying, "Drink from it, all of you, for this is my blood of the covenanting, which is poured out for many for the forgiveness of sin."

Adding, "Do this in remembrance of me," he institutes the Christian ritual of the Eucharist.

As it is often represented, the theme is charged with conflicting moods, among them solemnity (in the distribution of the bread), tenderness (the beloved disciple's head against his Lord's heart), and, with Judas stealing away in the background, sinister drama and suspense.

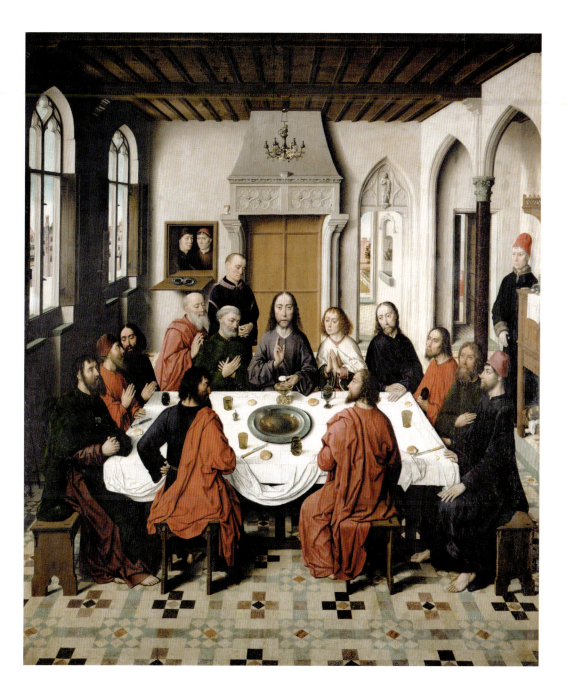

The Garden of Gethsemane

During their ministry, Jesus and his disciples often slept outdoors. After the Last Supper they left Jerusalem for the village of Gethsemane, on the Mount of Olives. There, Christ lay down a stone's throw from the others and began to pray. Knowing the fate in store for him, he suffered the agony of anticipation, sweating drops of blood and calling on God the Father, "Father, if you are willing, remove this cup from me; yet not my will but yours be done."

Twice that night he woke his disciples, asking them to watch and pray with him. A third time he shook them awake, saying, "Are you still sleeping and taking your rest? Enough! The hour is come; the Son of Man is betrayed into the hands of sinners. Get up, let us be going. See, my betrayer is at hand."

For Judas had entered the garden with a "band of men and officers of the chief priests and Pharisees … with lanterns and torches and weapons," together with "a large crowd with swords and clubs from … the elders of the people."

In paintings of this episode Christ is commonly depicted either praying a few steps from his sleeping disciples while an angel wipes the sweat from his brow, or leaning over the disciples to wake them. Botticelli, however, has set the scene at the beginning of Christ's ordeal. The angel is not comforting him but, rather, handing him a cup, symbolic not only of the Passion of the next day but of his imminent anguish in the Garden.

Sandro Botticelli
1444/45–1510

Christ on the Mount of Olives

Capilla de los Reyes
Granada
Spain

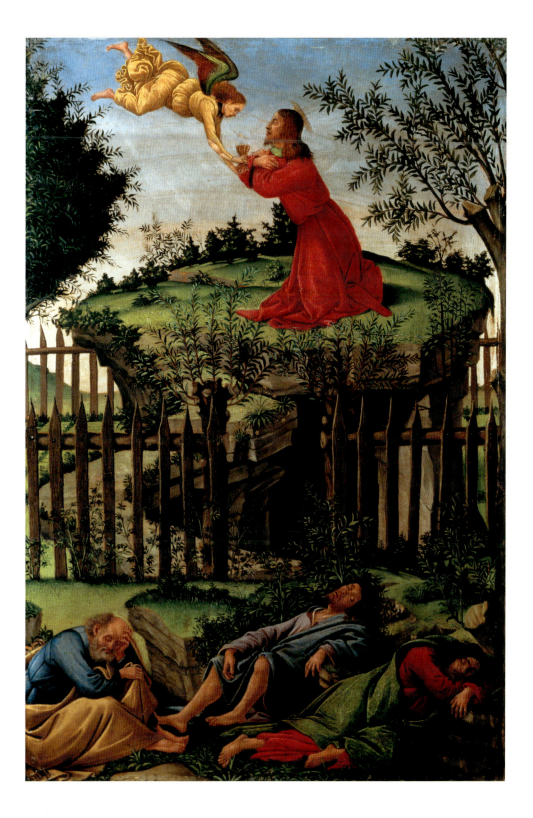

The Kiss of Judas

Judas was outraged by the fact that Mary Magdalene spread perfume over Christ's feet; to his mind it would have been better to sell it to provide alms for the poor. Yet he sold his master for only a tenth of the perfume's value—the paltry sum of thirty pieces of silver.

Coming into the garden, he told the guards, "The one I will kiss is the man; arrest him," then "came up to Jesus and said, 'Greetings, Rabbi!' and kissed him."

Jesus said, "Judas, is it with a kiss that you are betraying the Son of Man?"

The guards then came up, "laid hands on Jesus and arrested him."

The next day Judas was overwhelmed by remorse and tried to return the money but the priests refused it. And so he threw the coins onto the Temple steps and went off to hang himself.

"Thirty pieces of silver," the proverbial phrase for blood money, always evokes Judas's betrayal. It is not so well known that a public burial ground for the poor is called a "potter's field" because the thirty pieces of silver went to pay for Judas's grave in an unused empty field belonging to a Jerusalem potter.

Judas's tragic character and his treachery have inspired many texts sympathetic to him. The writings of certain Gnostic sects argue that he was, in fact, a saint. However, in the many somber paintings he has inspired he is always the personification of unctuous, abject treachery.

Fra Angelico
(Fra Giovanni da Fiesole)
c. 1395/1400–1455

The Kiss of Judas

San Marco
Florence
Italy

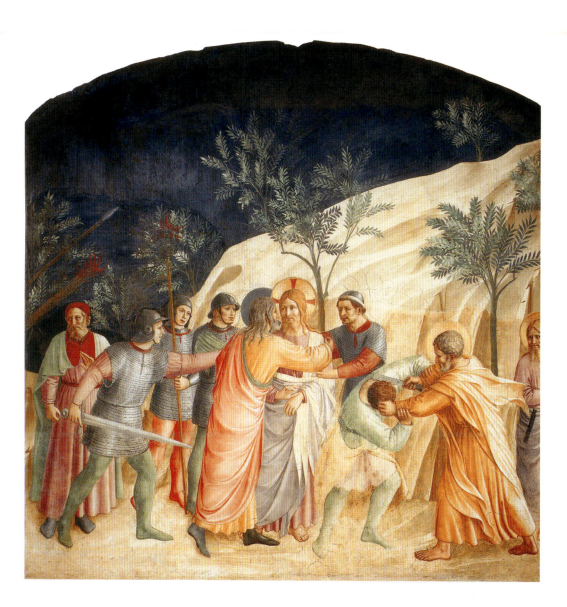

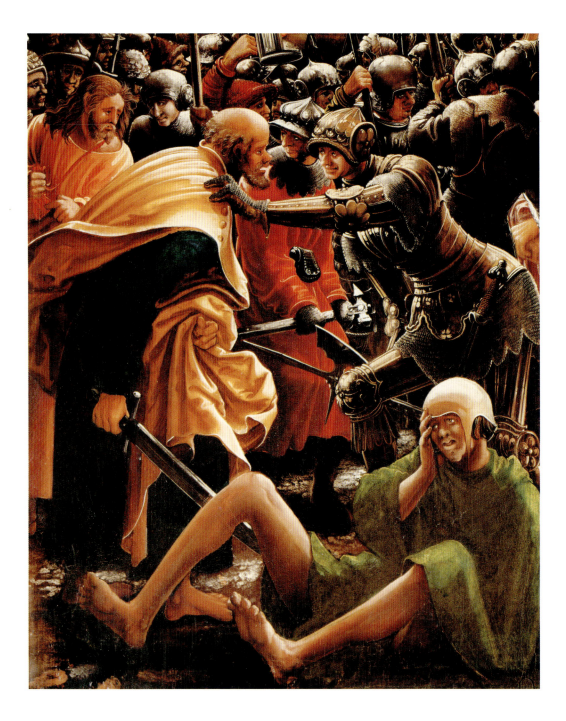

St. Peter's Blow with the Sword

Albrecht Altdorfer

c. 1480–1538

Christ's Arrest

St. Sebastian Altarpiece
Augustiner
Chorherrenstiftung
St. Florian
Austria

According to John, there was no Judas kiss. Jesus, "knowing all things that should come upon him, went forth and said unto them, 'Whom seek ye?'

"They answered him, 'Jesus of Nazareth.'

"Jesus said unto them, 'I am he.'" After confirming his identity a second time, he asked that the disciples be let go.

However, in all versions the arrest was tumultuous. The moment the guards seized Jesus the disciples rushed to defend him. Peter drew his sword and cut a small piece off the ear of the High Priest's slave, Malchus.

"Put your sword back into its place," Jesus said, "for all who take the sword will perish by the sword," and with a wave of his hand he performed his last miracle: the healing of Malchus's ear.

Then the disciples fled.

According to Mark, there was "a certain young man" among them who had been sleeping in the garden with "a linen cloth cast about his naked body." When the guards "laid hold on him … he left the linen cloth, and fled from them naked." Some commentators believe this to be Mark himself and this small detail of his sixteen-chapter Gospel the author's "signature."

Artists have often based their renditions of the disciples in confrontation with the soldiers on the tumultuous arrests of their own times, and have sometimes depicted scenes bordering on riot.

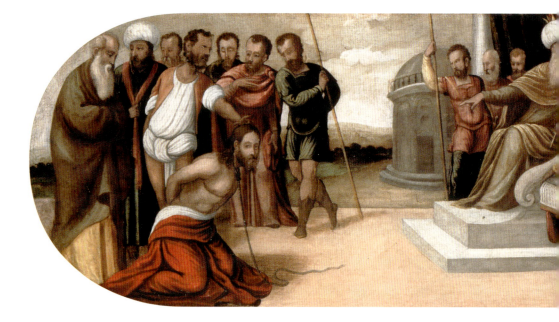

Jesus before Caiaphas

Even if the High Priests' verdict had been decided in advance, the semblance of a trial was necessary. Therefore Jesus was taken before Caiaphas, that year's high priest. Sitting with Caiaphas were the Sanhedrin, the plenipotentiary assembly of religious leaders.

Evidence for the prosecution was heard and sifted. False witnesses came forward but contradicted one another.

Throughout these proceedings Jesus kept silent. Finally, to Caiaphas' direct question, "Tell us if you are the Messiah, the Son of God," he deigned only this reply, "You have said so. But I will tell you. From now on you will see the Son of Man seated at the right hand of the Power and coming on the clouds of heaven."

To the priests, this was the capital crime of blasphemy. But as they lacked authority to issue the death sentence they remanded Jesus to the Romans.

Andrea Schiavone
(Andrea Meldolla)
c. 1510–1563

Christ before Caiaphas

San Giacomo dall'Orio
Venice
Italy

The Denial of St. Peter

Jan Miense Molenaer
c. 1610–1668

The Denial of St. Peter

Museum of Fine Arts
Budapest

At the Last Supper, Jesus told the disciples, "You will all become deserters because of me this night."

"I will never desert you," Peter said.

"Truly, I tell you," Jesus replied, "this very night, before the cock crows, you will deny me three times."

"Even though I must die with you," Peter said to him, "I will not deny you."

Peter's loyalty was such that he trailed the arresting party back to Caiaphas' palace in Jerusalem. A friendly servant let him slip into the courtyard to observe the proceedings. But a servant woman warming herself by a brazier thought she recognized him, and said, "You were with Jesus the Galilean."

"I do not know what you are talking about," Peter replied.

Another serving woman chimed in, "This man was with Jesus of Nazareth."

"I don't know this man."

But as he spoke with a Galilean accent, which was a provincial one to residents of a metropolis like Jerusalem, others said, "Certainly you are also one of them; for your accent betrays you."

Peter "cursed … swore an oath," and for the third time denied his Lord, crying, "I do not know the man!" At that instant the cock crew. "Remembering Christ's words," Peter "broke down," "wept bitterly," and left the courtyard.

The Gospels' accounts lend themselves to dramatic compositions of St. Peter on the defensive among women and armed men. About an equal number of paintings show the costumes and surroundings as they looked either in the painters' respective eras or in antiquity. In displacing the scene to a seventeenth-century Netherlands inn, Jan Miense Molenaer has eliminated all references to Jerusalem. Peter, though, is still the Gospels' emotional disciple.

Jesus before Pilate

When remanding Jesus to Pilate, the Temple priests must have had a fair idea of the annoyance they were causing this polytheistic Roman by asking him to condemn a man to death for blasphemy against their one God. The Evangelists are very clear about Pilate's thinking the case rather trivial.

Pilate interrogated Christ, understanding little about the case. When he learned that Christ was a Galilean, hence Herod's subject, he immediately remanded him to Herod, who was in Jerusalem at the time.

The Gospels do not recount Herod's interrogation of Christ but say only that he clothed him in a robe of royal purple and sent him back to Pilate.

Pilate interrogated Jesus again. When Jesus said, "Every one that is of the truth heareth my voice," Pilate answered like a good student of the Greek sophists, "What is truth?" He then abruptly left the hall and returned to the Jews waiting outside.

"I find no fault in him," he said, and made no move toward a sentence of death.

Juan Correa de Vivar's painting has conflated Christ's first appearance before Pilate with the last, at the end of which "Pilate … took some water and washed his hands before the crowd, saying, 'I am innocent of this man's blood,'" and went inside.

The now proverbial saying "I wash my hands of it" has also inspired artists.

Juan Correa de Vivar
c. 1510–1566
Pilate Washing his Hands
Museo de Santa Cruz
Toledo
Spain

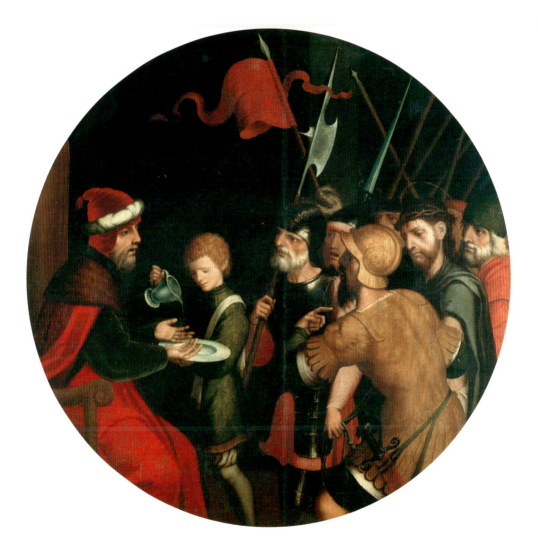

The Mocking of Christ

Pilate handed Jesus over to soldiers so that they could beat up this puzzling agitator, probably hoping that such a punishment would satisfy the priests.

The soldiers had understood the interrogation superficially. They amused themselves, then, by clowning around this "King of the Jews" dressed in purple. They put a reed scepter in his hands, prostrated themselves before him, then blindfolded him and spat in his face, saying, "Prophet, guess who struck you."

This Mocking of Christ has made a deep impression on Christianity. The theme of Christ suffering these outrages (another traditional title of the scene) was taken up regularly through the centuries.

Fra Angelico
(Fra Giovanni da Fiesole)
c. 1395/1400–1455

The Mocking of Christ

San Marco
Florence
Italy

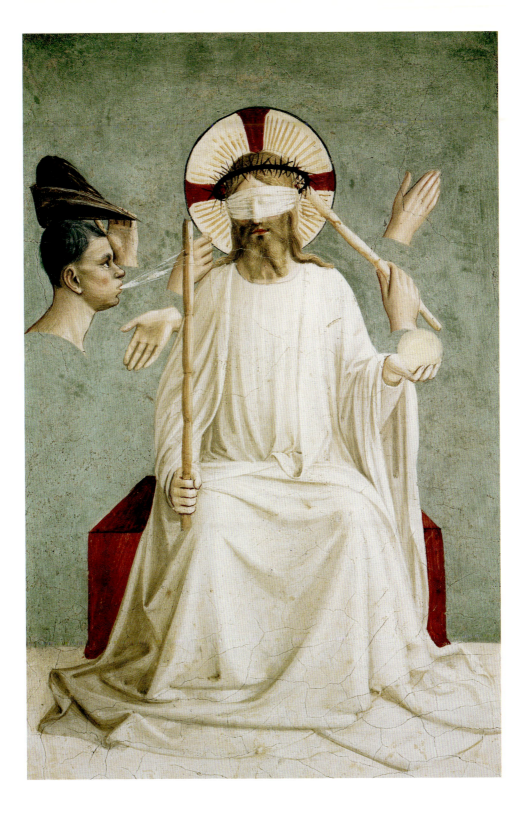

The Crown of Thorns

Still amusing themselves, the Roman soldiers crowned this "king" who had been given over to them with a wreath of thorns.

This wasn't deliberate torture. According to the Gospels, the soldiers merely "put" the crown on his head. However, for centuries preachers and painters have treated it as a prelude to the sufferings of the Cross, as in Juan Correa de Vivar's work here, in which the soldiers rudely force the crown down on Jesus's head with wands that allude to the Cross in their respective positions within the painting.

In the Gospels the Crown of Thorns is part of the Mocking of Christ, but painters have made it into an autonomous event. However, in this painting the facial expressions of the standing soldiers are compounded of both cruelty and mockery. Thus Correa de Vivar, while following the chronology established by painting, has nonetheless been faithful to the Scriptures' theme.

Juan Correa de Vivar
c. 1510–1566

The Crown of Thorns

Museo de Santa Cruz
Toledo
Spain

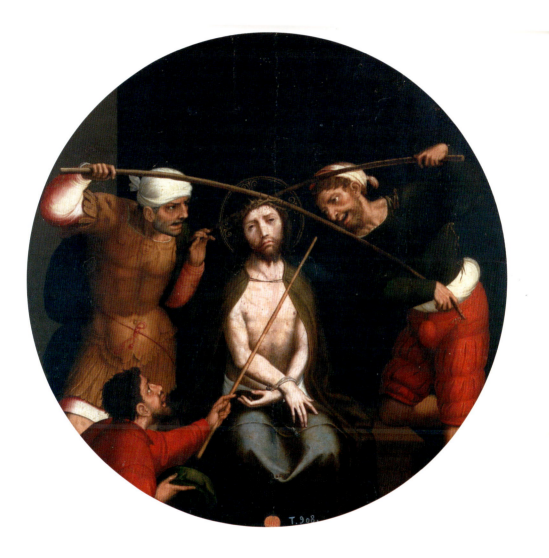

T.908.

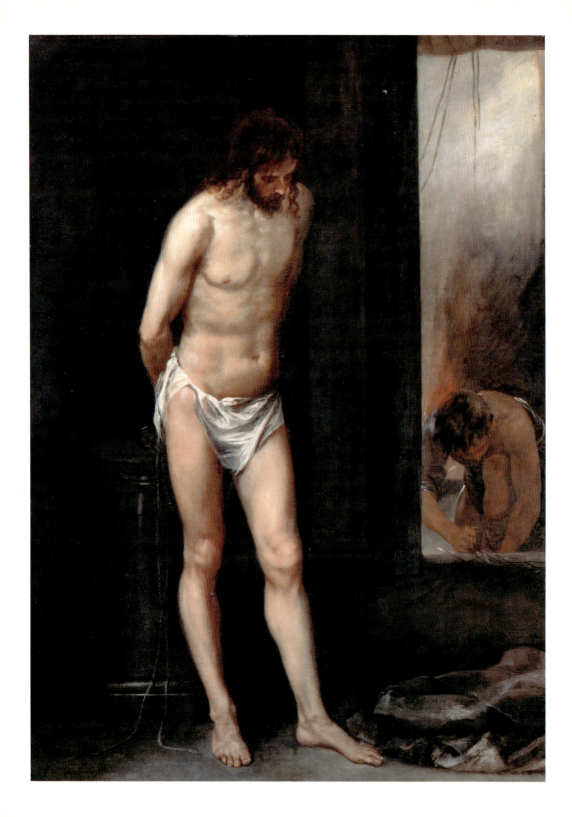

The Flagellation

Alonso Cano
1601–1667

The Flagellation of Christ

National Museum of Art
Bucharest

The only punishment ordered by Pilate himself was the flagellation. "I will have him flogged and release him," he told the priests.

Certain commentators have imagined that Pilate intended this first punishment as a means of weakening Jesus's body and so diminishing his resistance during his sufferings on the Cross. Although this is only speculation, it is supported by the true moderation with which the Evangelists credit the Roman governor. However, in contrast to Alonso Cano's painting seen here, pictorial tradition has frequently offered another interpretation, that of brutal torture. Piero della Francesca's *Flagellation* is one of the best-known paintings of this theme. Christ and his tormenter are small background figures in the open porch of a tranquil, airy, light-filled Roman courtyard. Christ's body is unmarked and his tormenter's arm is raised for the first blow of the scourge. In the foreground, richly dressed patricians, their backs to Christ, converse calmly. Thus Piero expresses a horror equal to if not greater than the Flagellation itself: the world's indifference to the cruelty about to take place; to cruelty itself; and to Christ's imminent death. Also expressed is the world's attention to worldly things despite the obviousness of spiritual imperatives.

"Ecce Homo"

To Pilate, all this uproar was over a case of an agitator charged only with driving some merchants from the Temple square. Moreover, while sitting in judgment he received a message from his wife, saying, "Have thou nothing to do with that just man: for I have suffered many things this day in a dream because of him," which stiffened his resistance to the death penalty. However, the priests alarmed him with veiled threats to denounce him to Rome for doing nothing against conditions that might lead to rebellion and for conniving at sedition. And so when Jesus was brought before him after the flagellation, he tried to have the crowd decide Jesus's fate.

He showed the tortured Christ to the crowd, saying, "*Ecce homo*" ("Here is the man.")

But the mob, which had been stirred up by the priests' agents, demanded crucifixion.

Pilate invoked the custom of granting amnesty to one prisoner during Passover. But still relying on the crowd, he had an infamous thief named Barrabas brought from jail and put next to Jesus.

"Which of the two do you want me to release to you?" Pilate asked.

"Barrabas!" the crowd roared.

"Then what shall I do with Jesus, who is called the Messiah?"

"Let him be crucified."

"Why, what evil has he done?"

"Let him be crucified," the mob cried. "His blood be on us and on our descendants."

"So," says Matthew, "when Pilate saw that he could do nothing, but rather that a riot was beginning," he said, "'See to it yourselves'" and handed Jesus over to them.

In traditional imagery, the mute Christ, still crowned with thorns, stands at Pilate's side before the raging crowd.

Hieronymus Bosch
c. 1450–1516

"Ecce Homo"

Städelsches Kunstinstitut und Städtische Galerie
Frankfurt
Germany

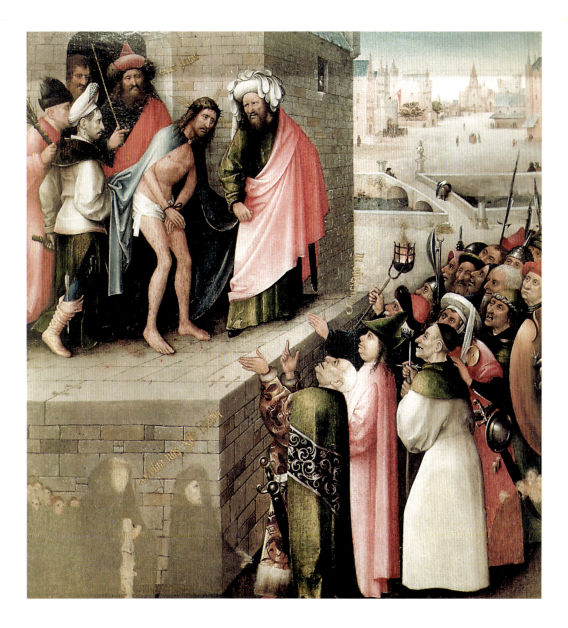

The Bearing of the Cross

Along the walls of all Catholic churches fourteen paintings or bas-reliefs comprise the traditional path of the Cross, known in English as the Stations of the Cross.

1st STATION: The Sentence of Death

2nd STATION: Jesus taking up the Cross

3rd STATION: First Fall

4th STATION: The Meeting with Mary

5th STATION: Simon of Cyrene

6th STATION: Veronica and the Holy Face

7th STATION: Second Fall

8th STATION: The Meeting with the Women of Jerusalem

9th STATION: Third Fall

10th STATION: Jesus Stripped of his Garments

11th STATION: The Crucifixion

12th STATION: Death on the Cross

13th STATION: The Descent from the Cross

14th STATION: The Entombment

However, iconography does not grant the same importance to all the stations. Some of them have been conflated into one station, others have been sharply individualized. For example, representations of Jesus falling beneath the weight of the Cross do not always clearly distinguish between the First, Second and Third Falls.

Pieter Brueghel the Younger
1564/65–1637/38

The Bearing of the Cross

Koninklijk Museum voor Schone Kunsten
Antwerp
Belgium

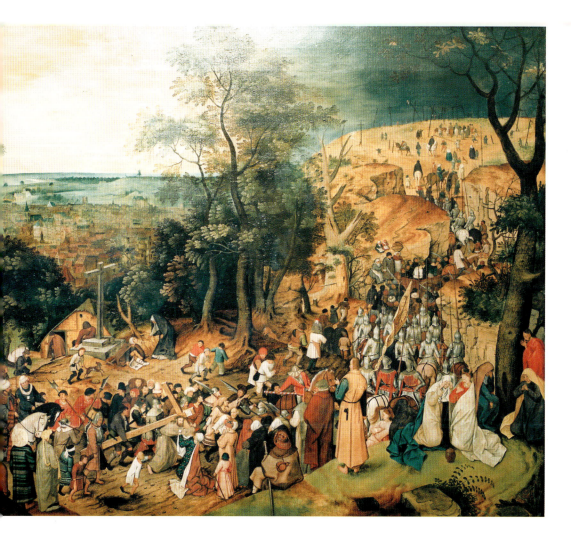

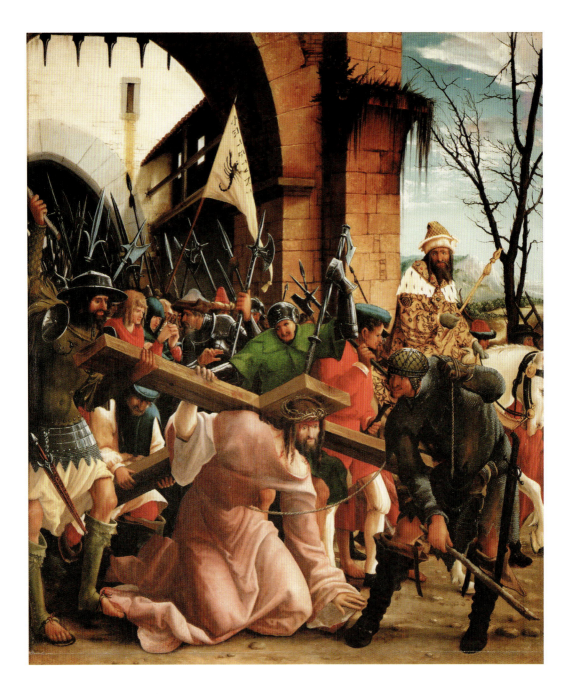

Simon of Cyrene

Albrecht Altdorfer
c. 1480–1538

The Fall

St. Sebastian Altarpiece
Augustiner
Chorherrenstiftung
St. Florian
Austria

On the way to Golgotha, "The Place of Skulls," situated beyond the city walls, the guards ordered a bystander to help Christ carry his Cross. His name was Simon and he had come to Jerusalem for Passover from his home in the Libyan city of Cyrene, the site of an important Jewish community. Luke says that he was the father of St. Paul's later associate Rufus.

Although the Gospels say that Simon of Cyrene was "compelled" to help Jesus, tradition has turned him into a symbol of pity. In many paintings we easily discern him, the one friendly face among the crowd of guards and indifferent onlookers. Depending on the painter's imagination and purposes, the depiction can concentrate more on the soldiers or on the crowd, or equally on both. The cumulative result is a range of paintings with a mixture of cruelty and compassion that varies widely.

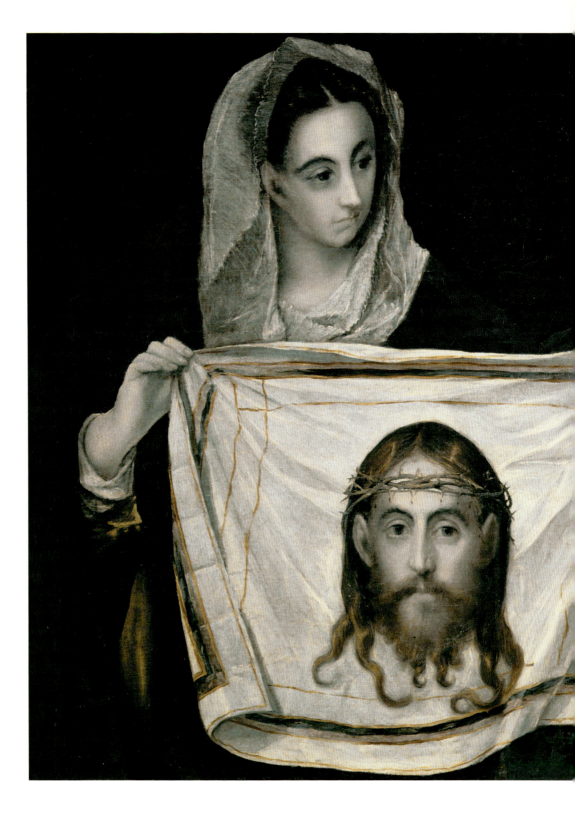

St. Veronica

The Gospels say only that among the "great number of people" who followed Jesus to the place of his execution were "women who were beating their breasts and wailing for him" and that Jesus told them, "Daughters of Jerusalem, do not weep for me, but weep for yourselves and for your children."

However, in the representations of the Sixth Station of the Cross, as Jesus is collapsing beneath his burden, a woman wipes his sweaty and bloody face with a piece of linen. Tradition has it that the image of his face remained on the cloth, which is now preserved at St. Peter's in Rome.

From two apocryphal documents of medieval origin, the Gospel of Nicodemus and The Death of Pilate, the woman has been named Veronica, although neither document places her in Jerusalem. Although never officially canonized, she has long been known as St. Veronica. The Roman Catholic Church gives her a saint's day, February 4. Since the Middle Ages, linen makers have accepted her as their patron saint, as is attested by many paintings. In 1839, she became the patron saint of photographers.

The Holy Face of Veronica must not be confused with the Holy Shroud, which retains the imprint of the dead Christ.

El Greco
(Domenikos Theotokopoulos)
1541–1614

St. Veronica with Christ's Sudarium

Museo de Santa Cruz
Toledo
Spain

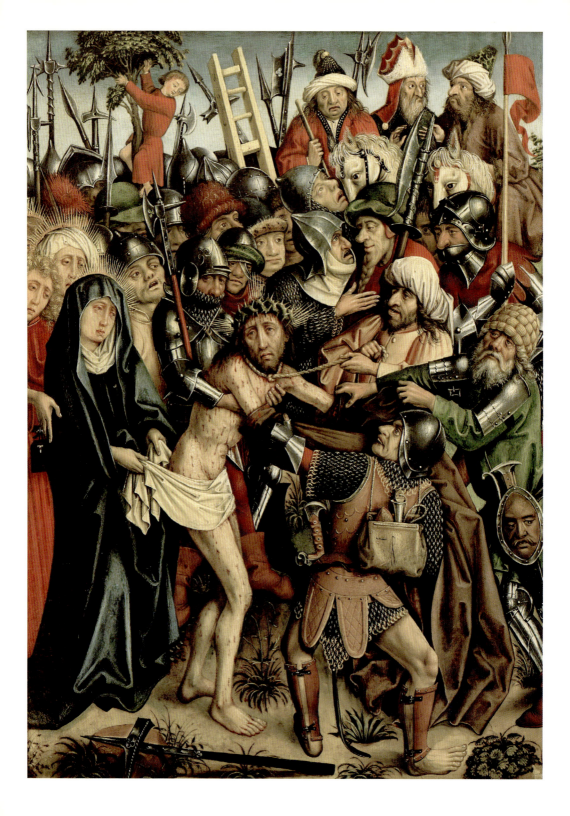

Jesus Stripped of his Garments

**Master of the Karlsruhe
Passion**
fl. c. 1435–1465

The Disrobing of Christ

Staatliche Kunsthalle
Karlsruhe
Germany

According to Roman custom, Jesus was disrobed before being put on the Cross. His four guards shared the spoils but hesitated at his robe, a piece of clothing woven without seams. Rather than tear it, they played dice for it.

Given Roman custom, he would have been stripped naked. However, in most paintings Christ isn't completely naked, the holy women having veiled his midriff with linen. On the other hand, the group of soldiers dicing for the tunic is included in a number of paintings without ever being central. Of greater importance is the seamless garment, in that it has become a symbol of the Church's unity.

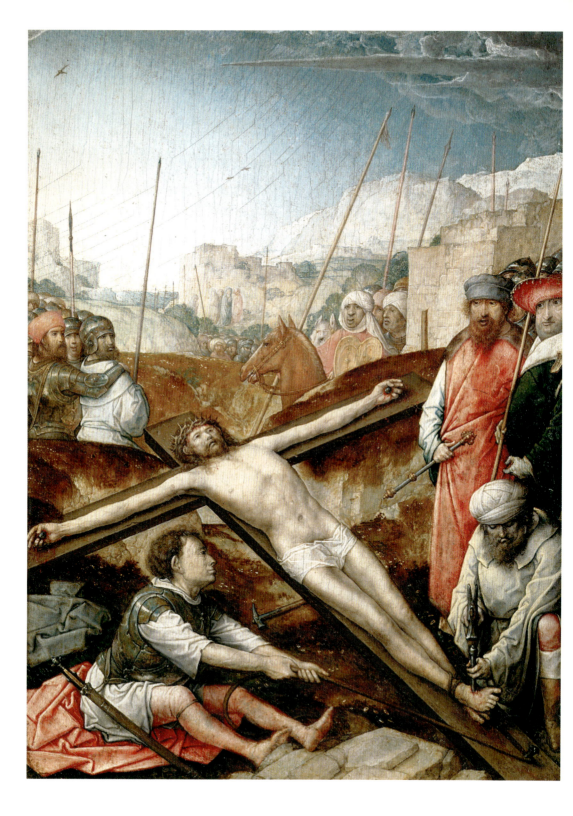

The Crucifixion

Juan de Flandes
c. 1465–c. 1519

Nailing Christ to the Cross

Kunsthistorisches Museum
Vienna

As the Passion is recounted in Western painting, the Cross is on the ground when Christ is put on it. And whereas the two thieves crucified with Jesus are seen attached to their crosses by rope, Christ is nailed to his. This detail is taken from the later words of St. Thomas, who refused to believe that Christ had risen until he saw the nail marks in his hands.

The scroll at the top of the Cross stands for the one Pilate ordered placed there, with "Jesus of Nazareth King of the Jews," written in Latin, Greek, and Hebrew. The iconography of Western paintings shortens this to "INRI," the acronym of the Latin, *Isus Nazarenus Rex Iudaeorum.*

In seventeenth-century France the small but briefly influential Catholic party known as the Jansenists characteristically represented Christ on the Cross with his arms above his head in the form of a "v," while the dominant Jesuits insisted on the image we know of Christ with his outspread, open arms. This dispute over imagery was an iconographic translation of the Jansenist–Jesuit controversy concerning the nature of Grace. The Jansenists held that it was reserved for a small number of the elect, the Jesuits that it was universally accessible.

Calvary

The word "Calvary," derived from the vulgar (that is, popular) Latin word meaning "skull," is a translation of the Aramaic "Golgotha," "The Place of Skulls." It now also means all depictions of the Crucifixion, in which Jesus is always flanked by the two thieves crucified with him. When one of them jeered, "Are you not the Messiah? Save yourself and us," the other rebuked him, "We indeed have been condemned justly ... but this man has done nothing wrong." Turning to Jesus, he said, "Jesus, remember me when you come into your kingdom."

"Truly, I tell you," Jesus replied, "today you will be with me in Paradise."

At the foot of the Cross one always finds the Virgin Mary, Mary Magdalene, Mary, the wife of Clopas, and St. John. According to John, Jesus looked down at Mary and said "Woman, behold thy son!" And to John he said, "Behold thy mother!" "From that hour," John continues, "that disciple took her unto his own house."

Nicola di Maestro Antonio d'Ancona's *Crucifixion* alludes to this moment by the placement and scale of both figures, by Mary's glance at John, and by the way John looks up as if taken by a sudden thought.

Painters sometimes include the soldiers sharing Christ's clothes or the crowd of Jews who, according to the Gospels, insulted Christ until he died.

They also sometimes paint a skull at the foot of the Cross, alluding to the name of the place but also to the tradition according to which Jesus died at the same place where Adam was buried. This latter iconographic meaning directly alludes to the larger idea that Christ's sacrifice on the Cross brought to a close the arc of human history begun with Adam's fall, a concept that can be traced back at least as far as St. Paul's statement (1 *Corinthians*), "For as in Adam all die, even so in Christ shall all be made alive."

Nicola di Maestro Antonio d'Ancona
fl. Ancona 1472–1510

The Crucifixion

Accademia
Venice
Italy

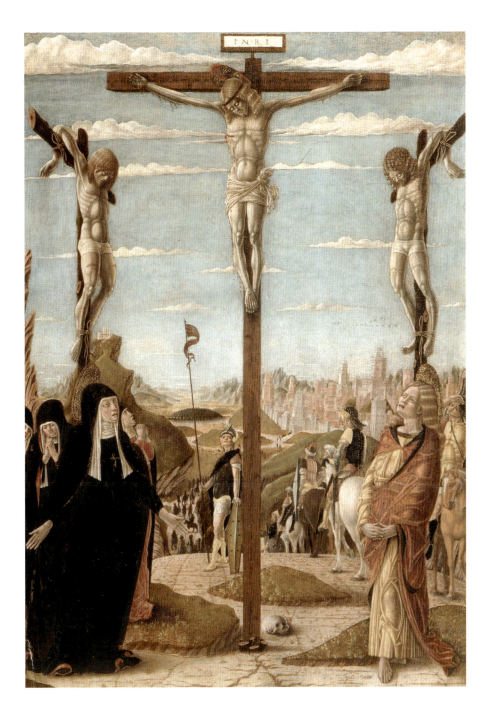

The Blow of the Spear

The Roman soldiers used their spears twice during the Crucifixion. The first time, as Jesus said he was thirsty, they soaked a sponge with a mixture of vinegar and water (a traditional Roman drink), and passed it up to him on the head of a spear.

The second time, as the sun was setting, ushering in the Sabbath, the Jews asked that the execution be shortened to avoid the corpses being left hanging overnight and being taken down during the Sabbath. So the Roman soldiers broke the two thieves' legs to hasten their deaths. When they turned to Jesus he looked already dead, but in a twinge of conscience one of them pierced him with his spear and blood and water flowed from him.

Depictions of the death of Christ require a somber sky, for at the moment that he died, darkness covered the earth, rocks split open, the dead rose from their tombs, and the Temple's great curtain tore in two.

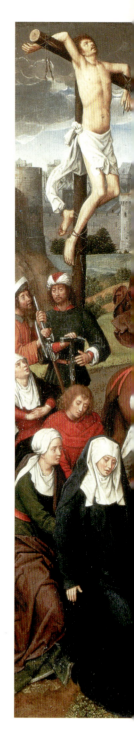

Hans Memling
1430/40–1494

The Crucifixion

Museum of Fine Arts
Budapest

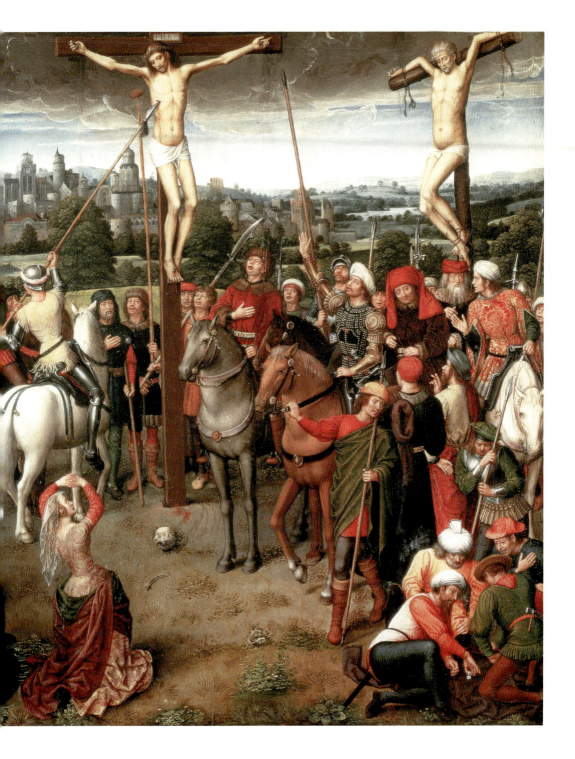

The Descent from the Cross

With the Descent from the Cross, painting introduces a new character in the Passion story, Joseph of Arimathea.

Arimathea is a small town about twenty miles from Jerusalem. Joseph was a member of the Temple council, but he disagreed with the majority opinion about Christ. Although he wasn't a disciple, he was at least sympathetic to Christ. It was Joseph whom Pilate authorized to take the body down, and who brought a shroud to wrap it in. Another character is sometimes depicted as well, Nicodemus, who brought the herbs used in embalming.

At their side we find once again the Saintly Women and the Apostle John.

Joseph also had rights to an unused tomb, hollowed out of a rock, that lay just at the edge of Golgotha. It was there that Christ's body was laid. Then the tomb was sealed by rolling a large rock over the cave mouth.

The Descent from the Cross and the Entombment bring the same protagonists in two episodes adjacent in time and space.

At the sides of many paintings of the Descent from the Cross and the Entombment stand groups of figures, quietly observing the action, or conversing among themselves, or suffused with solemn emotion. Iconographic symbols identify some of these as saints, either the canonized Evangelists Saints Matthew, Mark, Luke, and John, or as the non-biblical saint after whom the church commissioning the painting was named. Sometimes a cardinal or a bishop in ecclesiastical raiment is included, as well as the donor in secular clothes of the painting's time. In some cases, historical documents enable us to identify these figures not only by status but also by name.

Rogier van der Weyden
c. 1399–1464

The Descent from the Cross

Prado
Madrid

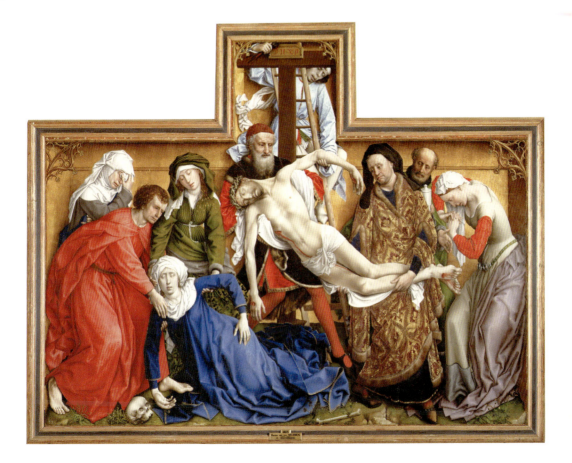

The Lamentation of Christ

In the tradition of Western painting, the Italian *pietà* and the Latin *mater dolorosa* denote a single scene of which there are numberless depictions: Jesus's body in Mary's arms. Sometimes the Virgin is surrounded by the saintly women and St. John. But these and other secondary characters are often omitted in order to concentrate the vision on the mother's tragic confrontation with the body of her son.

Enguerrand Quarton
c. 1420–*c.* 1466

The Avignon Pietà

Louvre
Paris

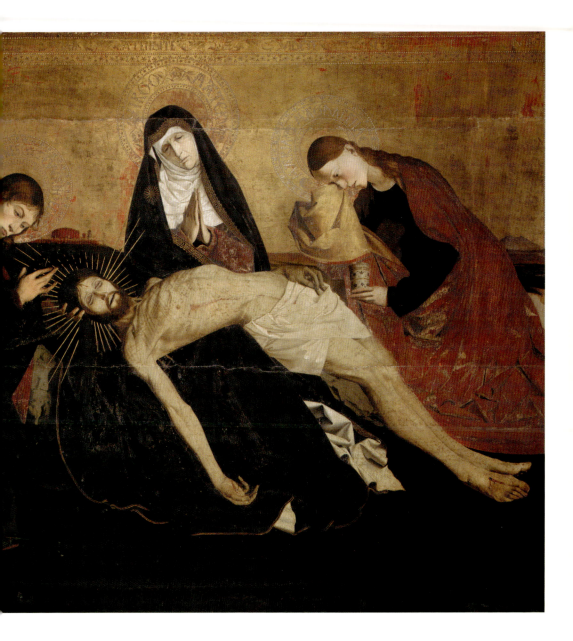

The Resurrection

Lest the disciples remove the body, the priests and Pharisees asked Pilate to have the tomb guarded. Once more the Roman governor was annoyed. "You have a guard of soldiers; so, make it as secure as you can." And so the Jews sealed up the entrance to the tomb and arranged for it to be guarded.

The morning after the Sabbath an angel of the Lord unsealed the rock. There was a great shaking of the earth and the terrified guards fell down as though dead. (They were not simply sleeping, as some painters have depicted them.)

As neither Mary and the saintly women nor the disciples actually saw Christ leave the tomb, the Gospels do not describe the event. But the glory of the Resurrection itself justifies the celebration of it in paintings for which there is no text to retell it iconographically.

In the background of Raphael's *Resurrection*, Mary and the other women are on their way to the tomb, carrying the spices the Gospels mention, in small, ornate urns. Thus the painting encompasses both an event the Gospels do not recount with one they describe in some detail. But Raphael has two of the women looking at each other as they converse along the way, and the third is looking reverently at her delicately designed urn. Thus he avoids implying that they saw the Resurrection even though he departs from the Scriptures by placing them within sight of the tomb at the very moment Christ rises from it.

Raphael
1483–1520

The Resurrection

Museu de Arte
São Paulo
Brazil

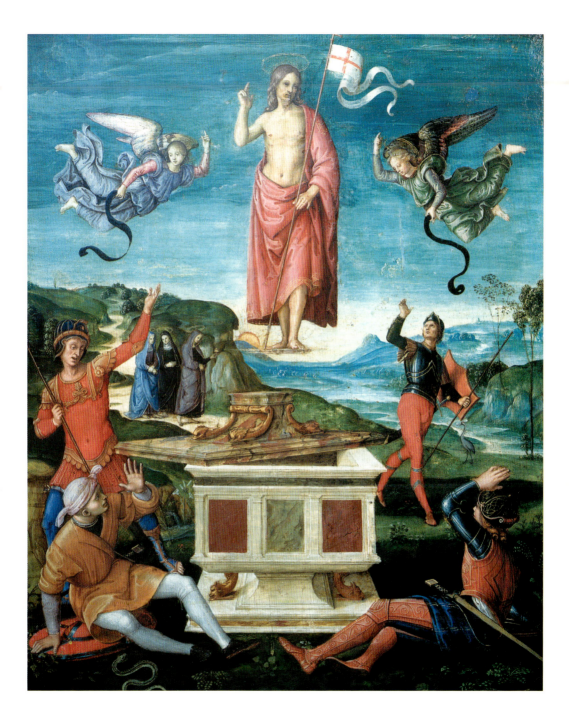

The Saintly Women at the Tomb

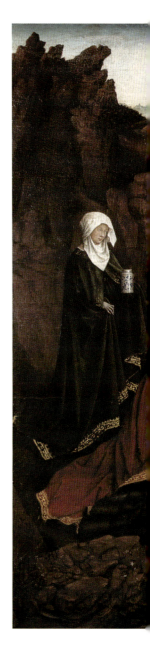

On the morning after the Sabbath, "while it was still dark," Mary Magdalene and two other women went to the tomb to anoint Jesus's body with spices. They found the tomb empty, the rock that had closed it rolled aside, and, seated by it, an angel in brilliant clothing who said, "Why do you look for the living among the dead? Go, tell his disciples and Peter that he is going ahead of you to Galilee; there you will see him just as he told you."

Frightened, they ran to tell the disciples, who thought them "telling idle tales." However, first Peter and then John rushed to verify in turn that the tomb was empty. Thus they understood that their Lord had come back to life.

Faithful to the Scriptures, Western paintings always show the three women and an angel. Sometimes the guards, lying still as death, and, infrequently, the two Apostles running breathlessly to the site, are also seen. But the tomb is rarely a cave dug into a hillside, as in both the Scriptures and the historical mid-Eastern tradition; rather, it is most often a sarcophagus of Greco-Roman antiquity. The Van Eycks' painting illustrates the wide latitude artists had with respect to many other obligatory details of the scene, like the urns that hold the spices, and the angel's costume and wings. Also, they have put a stylized, imaginary Eastern city in the background, with many variations on its turrets, cupolas, and spires, given the women the biblical costumes common to the paintings of their time, and dressed one of the soldiers in a Saracen robe and helmet and the other in European armor.

Hubert and Jan van Eyck
c. 1385/90–1426; *c.* 1395–1441

The Saintly Women at the Tomb

Museum Boymans–van Beuningen
Rotterdam
The Netherlands

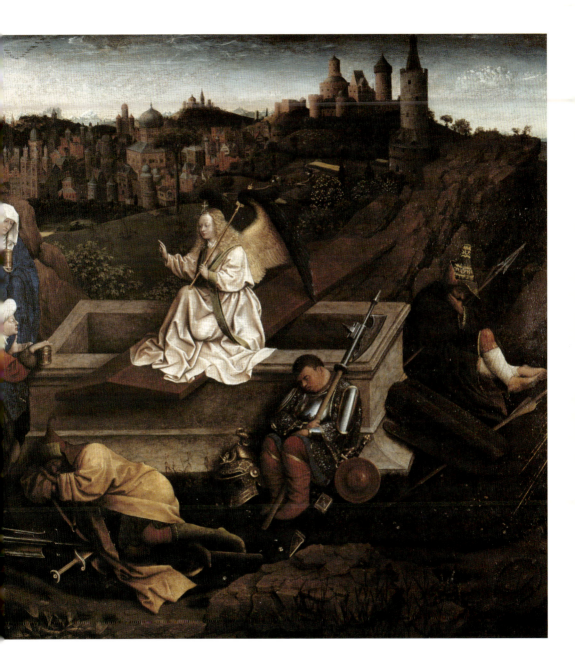

The Holy Shroud
(The Shroud of Turin)

When Peter came to Christ's tomb he stooped by the entrance, looked inside, and saw only the "linen cloths," the shroud provided by Joseph of Arimathea. "Then he went home, amazed at what had happened."

According to tradition, the shroud Peter found in the empty tomb bore the image of Christ's body. It was taken and preserved as a relic. During the Byzantine empire it was enshrined at Constantinople. During the Crusades it was taken to Chambéry, then passed to Turin, where it inspired great devotion. Its importance in the Scriptures, tradition, and worship made it a theme for paintings that are, in effect, images of an image. Nonetheless, certain paintings of it exceeded the status of art works and were taken for the shroud itself. Two were long enshrined at Cologne and Besançon.

Anonymous (Italian)
Painting on embroidered cloth
XVI century

Shroud with the Image of the Dead Christ

Santuario della Madonna di Monte Berio
Vicenza
Italy

The Apparition to Mary Magdalene

Knowing nothing of what had happened, the repentant sinner Mary Magdalene sat weeping by the empty tomb. Within the cave she saw two seated men, dressed in white, who asked the reason for her sorrow. Not realizing they were angels, she said simply, "They have taken away my Lord, and I do not know where they have laid him."

Behind her another man said, "Woman, why are you weeping?" Thinking him a gardener, she asked, "Sir, if you have carried him away, tell me where you have laid him." The man called to her again, in one word, "Mary."

Then she understood and replied in one word, "*Rabbouni*" ("my little master") and rushed to embrace him.

"Do not hold on to me," Christ said, "I have not yet ascended to the Father."

Then he sent her to tell the disciples that he had risen.

As written in St. Jerome's Latin Bible (the sole Bible of Western Europe until the Protestant Reformation, and known as the Vulgate), Christ's reply to Mary, "*Noli me tangere!*," has become one of the best-known Latin phrases in the Western world. Americans are most familiar with it from the flags of several colonies during the Revolutionary War, where it appears together with the image of a coiled snake, its head and upper body rearing back to strike.

Bronzino
(Agnolo Bronzino)
1503–1572

"Noli Me Tangere"

Louvre
Paris

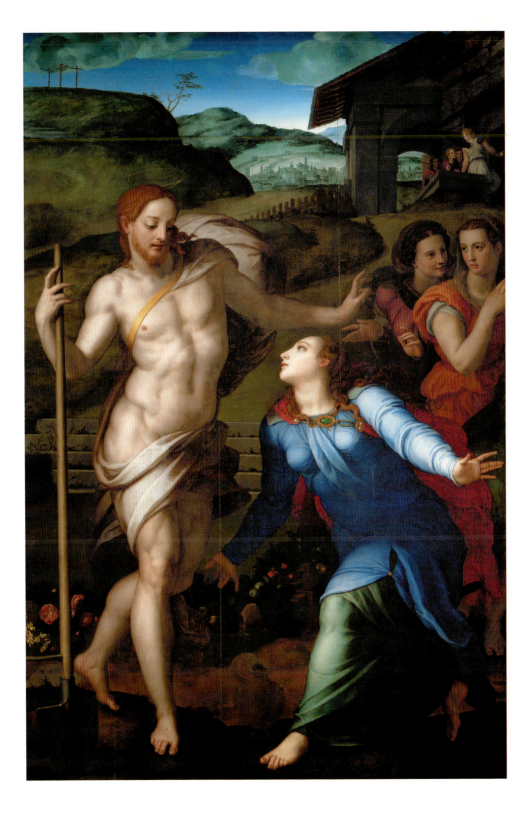

The Walk to Emmaus

In the evening of the day Christ's tomb was found empty, Cleophas and another disciple took a walk to the town of Emmaus, a short distance from Jerusalem. A traveler joined them along the way and asked them what they were talking about.

"Are you the only stranger in Jerusalem who does not know the things that have taken place there these days?" they asked in turn.

Cleophas told him the about the mighty prophet of Nazareth, "and how our chief priests and leaders handed him over to be condemned to death and crucified him. But we had hoped that he was the one to redeem Israel. Yes, and besides all this, it is now the third day since these things took place.

"Moreover," he said, "some women of our group astounded us." He then told the stranger about the report of the empty tomb and the angel's words saying that Jesus was still alive. Cleophas did not say that he believed the angel's words but only that when some of the disciples ran to the tomb it was indeed empty but the angel wasn't there.

"Oh, how foolish you are, and how slow of heart to believe," the traveler replied. And as they went along he pointed out to them how everything that had happened corresponded word for word with the prophecies of the Scriptures, beginning with Moses's.

Treatments of this episode differ sharply. Some versions show simply figures within a beautiful landscape; others concentrate on the theme of compassion and consolation: two bereaved travelers taking comfort from a mysterious stranger.

Claude Lorrain
(Claude Gellée)
?1604/05–1682

Landscape with Christ on the Road to Emmaus

Hermitage
St. Petersburg
Russia

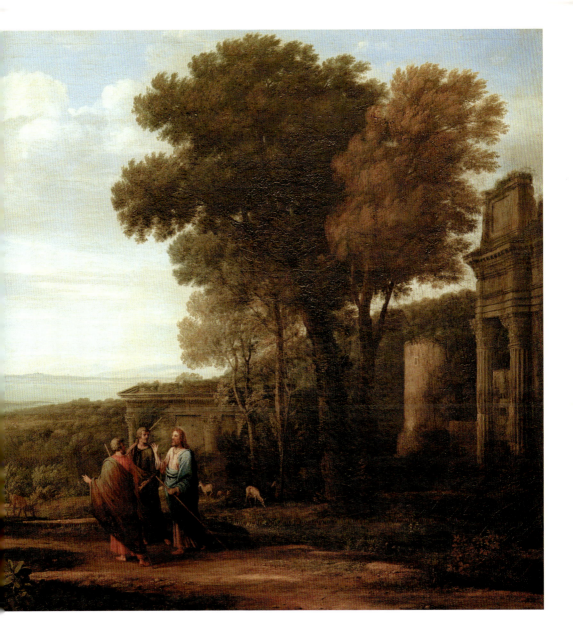

The Supper at Emmaus

At Emmaus, the stranger indicated that he would keep traveling but Cleophas and his friend invited him to dine with them. During the meal their guest took some bread, broke it, and handed it to them. It was only then that Cleophas and his companion, remembering the same act during the Last Supper, realized that their traveling companion was Christ, who vanished at the moment of recognition.

Wild with joy, the two men immediately set out for Jerusalem to share the news with the disciples.

For the Church, the essence of this story is not the disciples' sudden awareness that their Lord is with them but Christ's repetition of the Last Supper's sharing of the bread, with which he instituted the Eucharist. The prime theological importance of the moment is attested by the very numerous paintings dedicated to it, such as Marco Marziale's painting with its stillness and solemnity; the gradually brightening light, together with all the lines, lead to Christ's blessing of the bread as he looks not at the other guests but out at us—out, that is, through the centuries, almost as though he is repeating to the present the words he spoke to the disciples as he shared the bread with them at the Last Supper.

Marziale's painting was created just before the Protestant Reformation. A few decades after the Reformation, paintings of the Supper of Emmaus concentrated on the amazed disciples' shock of recognition, in dramatic contrast to Jesus's calm, benevolent compassion for the turbulence of their souls.

Marco Marziale
fl. 1492–1507

The Supper at Emmaus

Accademia
Venice
Italy

Doubting Thomas

Late in the day that Christ's tomb was found empty, the disciples met secretly in a room in Jerusalem. Fearing the Jews, they locked the door tightly. Suddenly Jesus appeared among them and said, "Peace be with you."

"They were startled and terrified," Luke says, "and thought that they had seen a ghost." Jesus calmed them. "Look at my hands and feet; see that it is I myself. Touch me and see; for a ghost does not have flesh and bones as you see that I have." He then asked for something to eat. They brought him broiled fish, and he "ate it in their presence."

He comforted them with words that linked him to the laws of Moses, the prophets, and the psalms, saying that they "must be fulfilled." Then he blessed them and left them with these words, implying their future mission, "If you forgive the sins of any, they are forgiven them; if you retain the sins of any, they are retained."

The disciple Thomas (called "the twin") was elsewhere that night. When he heard what had happened he refused to believe it. "Unless I see the mark of the nails in his hands, and put my fingers in the mark of the nails, and my hand in his side, I will not believe."

When Jesus appeared to the disciples again, Thomas was with them. Jesus said to him, "Put your finger here and see my hands. Reach out your hand and put it in my side. Do not doubt, but believe."

Taken aback, Thomas answered only, "My Lord and God!"

"Have you believed because you have seen me?" Jesus said. "Blessed are those who have not seen me and yet have come to believe."

Guercino
(Giovanni Francesco Barbieri)
1591–1666

Doubting Thomas

Residenzgalerie
Salzburg
Austria

The Ascension

Jesus reappeared to his disciples several times, as often in Galilee as in the outskirts of Jerusalem, explaining the significance of the Passion, eating with them, and telling them they would be baptized by the Holy Spirit.

He commanded them to set out "and make disciples of all nations, baptizing them … and teaching them to obey everything that I have commanded you. And remember, I am with you always, to the end of the age." Then he went away.

Luke places the Ascension in Bethany, near Jerusalem, in plain sight of the Apostles. In Acts, he adds that Jesus rose into the sky and when a mist veiled him from their sight two angels appeared, saying, "[He] will come in the same way as you saw him go into heaven."

As the last episode of Christ's life on earth, the Ascension before the prostrated Apostles brings the visible arc of his life to a close and has therefore been depicted often. Yet there are many fewer paintings of it than of the other two pivotal moments, the Nativity and the Death on the Cross. All three moments are at once human and divine; but when the Word is made flesh in a Bethlehem stable as a newborn babe adored by his parents, shepherds, and kings, or when the Son of Man dies in human agony on the Cross, under the eyes of his mother and his disciples, the scene is rich with opportunity for the depiction of human faces, gestures, and emotions. But in the Ascension, Christ is more divine than human, and the range of gestures and emotions in the other figures is narrow.

However, in this painting Mantegna has overcome these limitations with the poignant gesture of Christ's left hand, which at once blesses those below and waves them a gentle last goodbye. Humanizing, also, is the playfulness of the painter's variations on the motif of the cherubs.

Andrea Mantegna
1430/31–1506

The Ascension

Uffizi
Florence
Italy

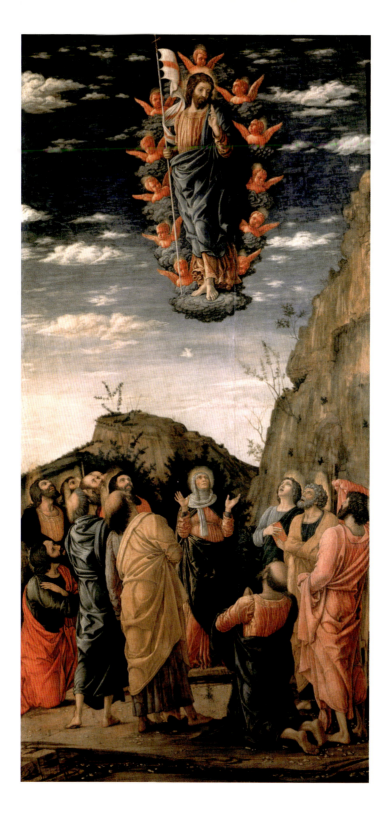

Pentecost

After the Ascension the disciples, numbering about one hundred twenty, remained together in Jerusalem and "constantly" devoted themselves to prayer.

Peter emerged as their leader and proposed that someone be chosen to take Judas's place among the twelve key disciples. Matthias was chosen by lots.

Fifty days after the Resurrection, all the disciples were praying together "in one place" when a great wind filled the house. "Divided tongues, as of fire, appeared among them, and a tongue rested on each of them."

Filled with the Holy Spirit, they "began to speak in other languages, as the Spirit gave them ability."

The sound attracted a crowd, including Jews from all around the Mediterranean seaboard as far as Persia and the Persian Gulf. Each one of them heard the words of the disciples in his mother tongue.

It was after Pentecost that the twelve disciples became the Apostles and began proselytizing in Jerusalem.

As tradition has placed the Virgin among the disciples, she customarily appears in Pentecost paintings along with the twelve Apostles and a dove symbolizing the Holy Spirit. The number of other disciples receiving divine grace varies from picture to picture.

In most paintings showing a group of the Apostles preaching to the people of Jerusalem, St. Peter is the only speaker.

Henri and Antoine Cibille
XVII century

Pentecost

Musée du Pays d'Ussel
Limousin
France

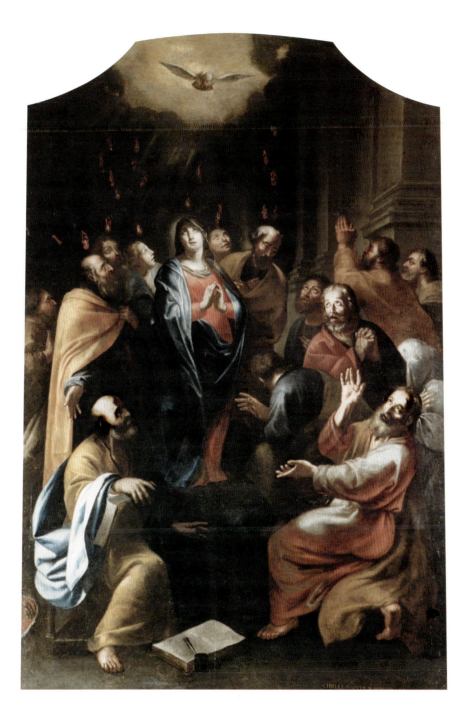

The Dormition of the Virgin.

Because at her death the Virgin Mary lay in state for three days, her body showing no signs of corruption, and then was assumed into heaven, her death has been given the term "dormition," a death that resembles falling asleep.

Accounts of the Dormition are found only in much later apocryphal Greek, Latin, Syriac, Coptic, Arabic, and Ethiopian texts assigned to various authors, including St. John the Evangelist and Joseph of Arimathea. They date the Virgin's death from as early as three and as late as fifty years after the Ascension.

Mary learned of her approaching death from maidens who had a vision of it, or from angels who appeared to Mary at the Holy Sepulcher, or from Jesus himself. In some versions, the Apostles are in Jerusalem with her, in others many of them are divinely brought there from Ephesus, Alexandria, Thebes, Rome, "out of the utmost Indies," and from a ship at sea. Five were raised from the dead by the Holy Spirit, who said, "Think not that the resurrection is now: but [ye are] risen up out of your graves, that ye may go to salute … the mother of your Lord … for the day is come near of her departure."

As the Apostles watched at her bedside many sick people gathered outside the house and were healed by touching its walls. God appeared to Mary, who prayed to him as God the Father "to have mercy upon the world" and as God the Son "to glorify them that glorify thee through my name." Mary's face shone, she blessed the Apostles, and Jesus received her soul into heaven.

Accepted reverently by the faithful, these accounts have inspired many Western painters. Most works show the Virgin lying in state with the reassembled Apostles gathered round her bed. Above her, Christ stands to welcome her soul, which is often symbolized by the figure of a small child.

Hugo van der Goes
c. 1440–1482
The Death of the Virgin
Groeningenmuseum
Brussels

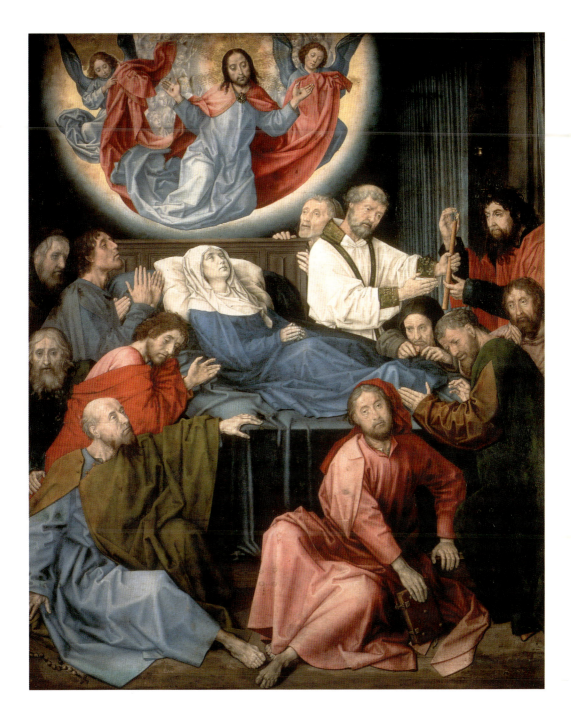

The Assumption

Made official dogma by the Vatican in 1950, the Assumption has been accepted as fact since antiquity.

Conceived without sin, the Virgin could not know corruption. However, unlike her son, she could not come back to life. Nor could she ascend to heaven by herself. Therefore, angels raise her to Paradise while yet alive

According to the apocryphal texts, when the Virgin closed her eyes the Apostles "bare the bed and laid her precious and holy body in Gethsemane in a new tomb. And lo, an odour of sweet savour came out of the holy sepulchre." For three days "the voices of invisible angels were heard" in the tomb. At the end of the third day the voices ceased, "and thereafter we all perceived that her spotless body was translated into paradise." There was great joy on earth and in heaven.

In paintings of this theme, Jesus stands in Paradise, sometimes accompanied by God the Father and the Holy Spirit, and prepares Mary's welcome.

The important iconography dedicated to this event attests the antiquity and depth of belief in it, even if the Catholic Church was slow to make it official.

El Greco
(Domenikos Theotokopoulos)
1541–1614

The Assumption over Toledo

Museo del Greco
Toledo
Spain

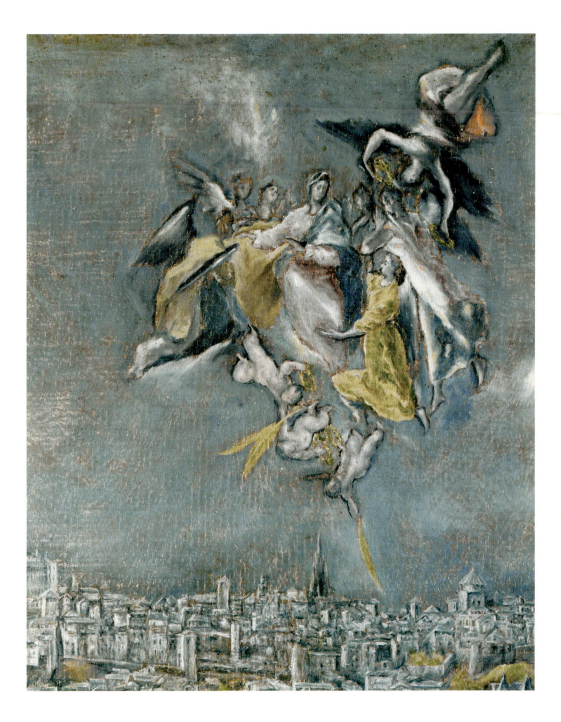

The Coronation of the Virgin

For painters of the Coronation of the Virgin, the story has been less important than its meaning. Paintings have not illustrated a moment in the Virgin's life; rather, they have symbolized two basic elements of Christian faith: the cult of Mary and the Holy Trinity.

In the presence of a dove, symbolizing the Holy Spirit, God the Father and God the Son together place the crown on Mary's head. But the honor has not elevated the Virgin to divine status. Therefore, to emphasize her secondary place in the celestial hierarchy, certain artists have depicted her from the back.

Very popular from the Middle Ages forward, this theme enjoyed an increased popularity during the Counter-Reformation, when the Catholic Church strengthened the Marian cult as a defense against Protestant attacks.

Diego Velázquez
1599–1660

The Cornation of the Virgin

Prado
Madrid

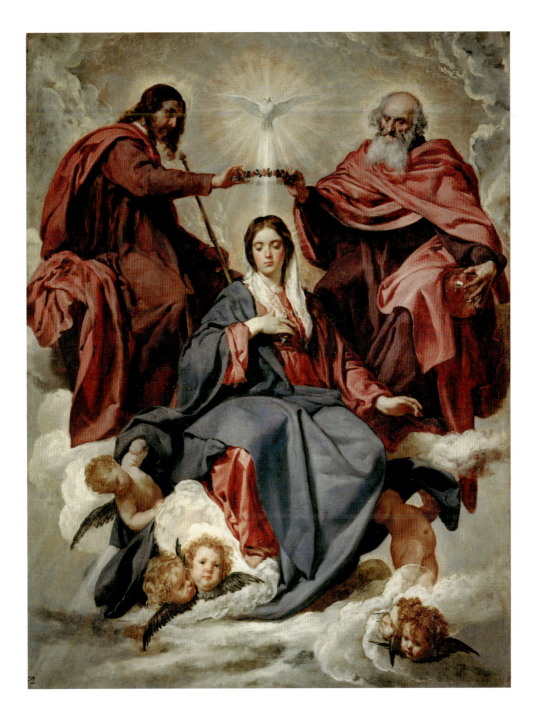

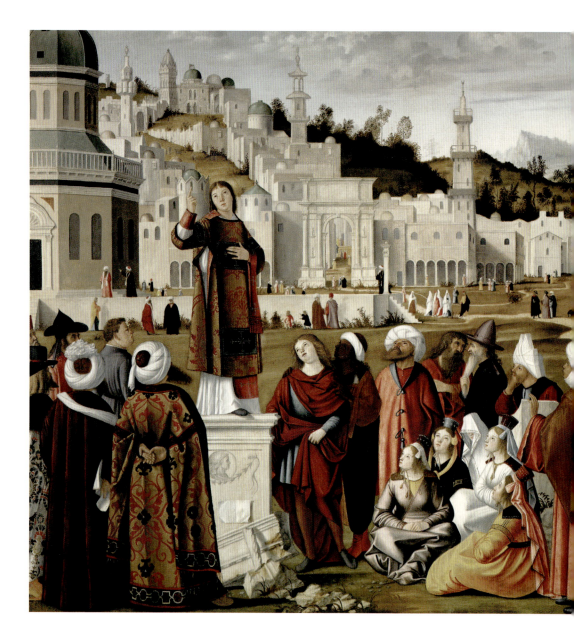

The Martyrdom of St. Stephen

In the days following Pentecost, the Church began to be structured and seven deacons were appointed to assist the Apostles. The first was Stephen, a Jew of the Diaspora, or "Hellenist," who began to preach with such fire that he was called before the Sanhedrin. There, in front of the assembled priests, he threw himself into a long, vehement discourse in which he accused the Jews of the past of betraying the divine covenant. "Which of the prophets did your ancestors not persecute? They killed those who foretold the coming of the Righteous One, and now you have become his betrayers and murderers."

Outraged, the priests dragged him out of the city and had him stoned to death. His executioners took off their clothes and gave them for safe keeping to a bystander named Saul—the future St. Paul.

Stephen, the first martyr of the infant Church, is most often depicted at the moment of his execution, hence in the presence of the Pharisee Saul, and dressed in the dalmatic, the liturgical vestment of deacons.

In so far as he is the patron saint of preachers, he is also sometimes painted in the performance of his ministry, enthralling the crowd in Jerusalem.

Vittore Carpaccio
?1460/66–1525/26

The Sermon of St. Stephen

Louvre
Paris

Simon Magus

The Samaritan sorcerer Simon Magus, famous for his feats of magic, was converted by Philip the Evangelist.

Some time after his conversion he watched Peter and John preaching and baptizing in Samaria, and laying "their hands" on the new converts, who "received the Holy Spirit" from them. He envied them this power and offered them money for it. "May your silver perish with you," Peter cried, "because you thought you could obtain God's gift with money."

Simon repented and asked Peter to pray that his words would not come true, and the Scriptures say no more about him.

But Simon Magus lives forever in Christian tradition and history, and in literature and legend.

According to Tertullian, he taught his own version of Christianity, which informed the first Gnostic heresy (second and third centuries A.D.). According to Justin Martyr, he was in Rome during Claudius' reign (A.D. 41–54), where his feats of magic popularized his preaching and his disciples honored him as a god. According to St. Hippolytus, he occasionally debated publicly with Saints Peter and Paul in Rome.

Christian tradition immortalized Simon as an emblematic figure. The sinful practice of buying and selling the priesthood and ecclesiastical advancement, "simony," is named for him; it was among the severest crimes of which Protestants accused the Church of Rome.

Simon is apostrophized by Dante in the *Inferno* as Dante and Virgil enter the circle deep in hell where simony is punished: "Ah, Simon Magus, and you his wretched followers, who, rapacious, prostitute for gold and silver the things of God, which should be brides of righteousness … ." In legend, he lives on into the Renaissance as an epitome of the blasphemous sorcerer and is thought to have given rise to the legend of Faust.

Filippino Lippi
c. 1457–1504

Peter and Simon Magus before Nero

Cappella Brancacci
Santa Maria del Carmine
Florence
Italy

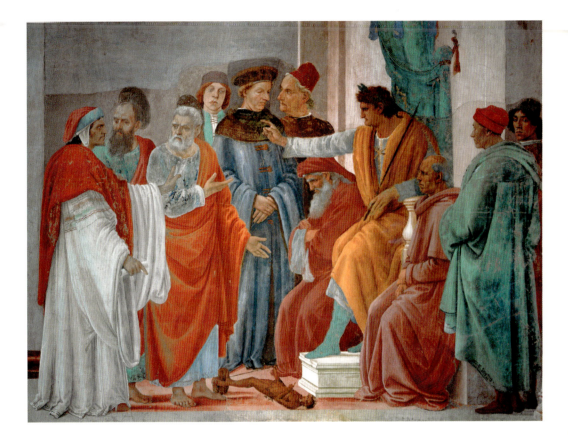

The Road to Damascus

Saul, a Jew from Tarsus in Cilicia, was a Roman citizen but educated by the rabbis of the Temple in Jerusalem. When he joined the Pharisees in their early persecution of the infant church he was so virulent that the Jerusalem Christians named him "the Abortion."

He was sent to Damascus as a plenipotentiary of the high priests, charged with organizing the repression of a newly formed church in the Jewish community.

On the road as he was nearing the city, a great light enveloped him and he fell to earth. A voice then called out, "Saul, Saul, why do you persecute me?"

"Who are you, Lord?" Saul asked.

"I am Jesus, whom you are persecuting. But get you up and enter the city, and you will be told what to do."

Saul rose up blind and his companions had to lead him by the hand into the city.

God then appeared to a Damascene Christian named Annaius and commanded him to heal Saul, who "has seen in a vision a man named Annaius come and lay his hands on him so that he might retain his sight … . At this moment he is praying." The thought of rendering such a service to such an enemy astonished Annaius. Nonetheless, he performed it.

Saul was baptized immediately thereafter.

According to his own account, he chose his new name, in Latin "Paulus," meaning "little one," out of humility.

Paul's favor among artists can be explained by the spectacular nature of his conversion and the suddenness of his change of heart, as well as by the major role he went on to play in the formation of the early Church and of its doctrine.

"The Road to Damascus" has become a proverbial phrase for a sudden enlightenment and a sudden change of mind or heart.

Bartolomé Estebán Murillo
1618–1682

The Conversion of St. Paul

Prado
Madrid

The Miracle at Lystra

Accompanied by Barnabas, a Cypriot Jew and one of the first disciples, Paul threw himself into intense missionary activity that was often charged with misunderstandings and risks.

As he was speaking to a crowd in the Galatian city of Lystra in Asia Minor, he noticed a cripple listening attentively, and said to him, "Stand upright on your feet." Miraculously healed, the man began to jump up and down.

The crowd was galvanized, for they knew the man "could not use his feet and never walked, for he had been crippled by birth." A shout went up, "The Gods have come down to us in human form."

The rumor spread throughout the city, calling Barnabas Zeus, and Paul the gods' messenger Hermes, "because he was the chief speaker." The priest of the Temple of Zeus came rushing toward them with bulls festooned for sacrifice.

Paul and Barnabas tore their clothes, a sign of distress, and shouted, "We are mortals, just like you." Nonetheless, they only barely kept the crowd from sacrificing to them.

The situation became threatening when some Jews from Antioch and Ionium, recognizing Paul and Barnabas as Christians, stirred up the crowd against them.

All but idolized a few moments before, Paul was stoned and left for dead.

Artists have focused, rather, on the miracle itself, or on the risks run by Paul.

Karel Du Jardin
1626–c. 1678

St. Paul Healing the Cripple at Lystra

Rijksmuseum
Amsterdam

Paul in Athens

Paul's ministry took him to Athens, a "city full of idols, the sight of which," says Acts, "deeply distressed him."

Nonetheless, he "argued" in the synagogue and debated with Stoic and Epicurean philosophers in the marketplace. Soon Stoic and Epicurean philosophers and the general intellectual community of Athenians and foreigners in this cosmopolitan city became curious about him and invited him to speak at the Areopagus.

"I see how extremely religious you are," he began. "For as I went through the city and looked carefully at the objects of your worship, I found among them an altar with the inscription, 'To an unknown god.'" The audience listened attentively as he went on to proclaim that this unknown deity was in fact the one God of creation who urges humankind to repent, but when he said that God "has fixed a day on which he will have the world judged in righteousness by a man whom he has appointed, and of this he has given assurance to us all by raising him from the dead," an argument arose. Some "scoffed" at the Resurrection, and others said, "We will hear you again about this." Paul stopped speaking and a little while later left Athens, taking converts with him.

Thus emerged the misunderstanding, and indeed the schism, between nascent Christianity and Classical paganism in this, their first confrontation. It is this misunderstanding that has engaged the attention of artists nourished by the double tradition of Christianity and humanism.

Januarius Zick
1730–1797
St. Paul in Athens
Kunsthistorisches Museum
Vienna

Paul in Ephesus

Proselytizing in Ephesus, St. Paul performed miracle after miracle. This put him in direct competition with Jewish exorcists who healed the sick by magic. However, the superiority of Paul's healing was evident and conversions multiplied.

The city of Ephesus was then witness to a spectacle that has prefigured many like it down to the present day. The new converts brought their books of magic and burned them in public. St. Luke estimates the value of all these destroyed works at fifty thousand pieces of silver.

As sixteenth- and seventeenth-century painters who depicted this first Christian auto da fé celebrated the event, so did the seventeenth-century French playwright Pierre Corneille glorify his hero Polyeucte, a new convert who destroys idols.

Eustache le Sueur
1616–1655

*St. Paul
in Ephesus*

Louvre
Paris

The Four Evangelists

Of the four Gospels retained by the canonical texts, only two are written by one of the original twelve Apostles, Matthew the publican and John the beloved disciple. St. Luke, who also wrote Acts, was one of Paul's intimates, while Mark was a member of Peter's company.

Tradition has assigned a symbol to each Evangelist: the eagle to John, the lion to Mark, the bull to Luke, a youth to Matthew. These figures are borrowed from a passage of the Apocalypse (which is inspired by the prophet Ezekiel. "And there in heaven stood a throne … . Around the throne … are four living creatures … the first living creature like a lion, the second living creature like an ox, the third living creature with a face like a human face, and the fourth living creature like a flying eagle." Between these and the throne is "a Lamb standing as though it had been slaughtered … ."

And so some paintings regroup these symbols of the Evangelists around a lamb, symbolizing Christ, and sometimes these symbolic figures are carrying a book. But most often the four saints have human form and are accompanied by their symbols. As this poses a certain problem because the young man symbolic of Matthew would add a fifth human figure to the group, painters frequently avoided this confusion by transforming the youth into an angel or, as in Pieter Aertsen's painting, into a cherub. Another animal often present in such compositions is the dove, symbolic of the Holy Spirit, who inspired the authors of these holy books.

It was also customary to present St. John as he is traditionally depicted in other paintings showing the Apostles: fair-haired and much younger than the other Evangelists.

Pieter Aertsen
1507/08–1575

The Four Evangelists

Suermondt-Ludwig Museum
Aachen
Germany

St. John at Patmos

According to tradition, the Apostle John was condemned to martyrdom in Rome but escaped unharmed from a cauldron of boiling oil and lived out the rest of his life in exile on the Dodacanese island of Patmos, where he wrote the Apocalypse, or Revelation.

Tradition also has it that he transformed the magician Cynops, priest of Apollo, into a rock and performed other miracles. A rock of Cynops is still shown to visitors, as is a grotto where John is said to have dictated Revelation to his disciple Prochoros.

John is most often depicted composing his book, accompanied by his symbol, the eagle, as in Berto di Giovanni's painting. Sometimes his miracles are also represented in the distant background.

Because of its association with John, Patmos is often called "the Jerusalem of the Aegean."

Berto di Giovanni
fl. 1488; died *c.* 1529

St. John on Patmos

Galleria Nazionale
dell'Umbria
Perugia
Italy

The Dragon of the Apocalypse

The Apostle John's prophetic, obscure, lyrical visions have given rise to paintings that are sometimes as difficult to interpret as the text itself. His Revelation (in Greek, "*Apocalypse*") presents seven seals, seven trumpets, seven signs, and seven bowls, and teems with strange allegorical animals that have given painters' imaginations free rein. In the abundant iconography of Apocalypse paintings, two themes dominate. One is that of the Four Horsemen of the Apocalypse, mounted respectively on a white horse, a horse the color of fire, a black horse, and a pale horse, personifying, in turn, conquest, war, famine, and death.

The other theme is the Woman and the Dragon, symbolic of the Church and the Devil. Crowned with stars, and with the moon at her feet, the woman is seen in the pangs of childbirth or as a mother holding her child. The Dragon with seven heads is struck to earth by the Archangel Michael.

Peter Paul Rubens
1577–1640
The Woman of the Apocalypse
Alte Pinakothek
Munich
Germany

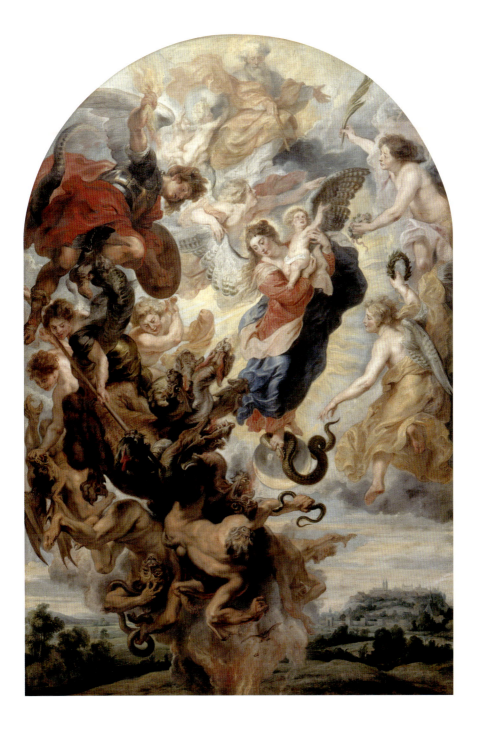

The Last Judgment

At the end of the world all nations will be gathered before Christ, who will place the elect at his right hand and the damned at his left. Proclaimed by St. Matthew, this judgment of nations will take place in the Valley of Jehosephat, as specified by the prophet Joel.

In early Christian art, the Last Judgment was represented in sculpture groups above the main doors of churches and cathedrals. Later, painters took up the theme and scenes of the Last Judgment became traditional in the decoration of church interiors. According to the sixteenth-century French poet François Villon, his mother saw the Last Judgment thus in her parish church: "Painted heaven with harps and lutes, and then hell where the damned are boiled."

The theme is often treated as a triptych: the central panel shows Christ in the act of judgment; the left and right panels, the felicities of paradise and the torments of hell. Over all, the tortures reserved for the damned, which are full of movement, have inspired artists more than the beatitude of the elect.

By contrast, Paradise has become the province of writing, which can lend movement to what is, for painters, a static theme. At the end of John Bunyan's *The Pilgrim's Progress* (1678), Christian and Hopeful reach the Heavenly City:

> and lo, as they entered, they were transfigured, and they had raiment put on that shone like gold. There was also that met them with harps and crown … the harps to praise withal, and the crowns in token of honour. Then … all the bells in the city rang again for joy … .
>
> Now, just as the gates were opened … behold, the City shone like the sun; the streets also were paved with gold, and in them walked many men, with crowns on their heads, palms in their hands, and golden harps to sing praises withal.

Hans Memling
1430/40–1494

The Gates of Paradise; The Descent to Hell

Museum Pomorskie
Danzig
Poland

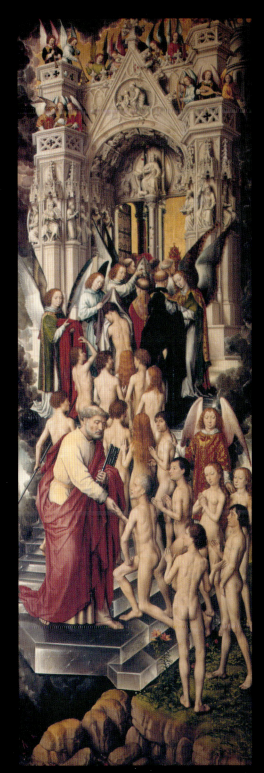
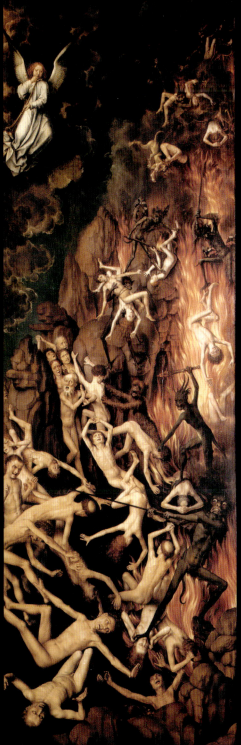

First published in English in 2004 by
Merrell Publishers Limited

Head office
42 Southwark Street
London SEI IUN

New York office
49 West 24th Street, 8th floor
New York, NY 10010

www.merrellpublishers.com

Publisher Hugh Merrell
Editorial Director Julian Honer
US Director Joan Brookbank
Sales and Marketing Director Emilie Amos
Sales and Marketing Executive Emily Sanders
Managing Editor Anthea Snow
Editor Sam Wythe
Design Manager Nicola Bailey
Production Manager Michelle Draycott
Design and Production Assistant Matt Packer

First published as *le Nouveau Testament à travers 100 chefs-d'œuvre de la peinture*
in 2003 by Éditions des Presses de la Renaissance
12 avenue d'Italie, 75013 Paris

British Library Cataloging-in-Publication Data:
Debray, Regis, 1941–
The New Testament through 100 masterpieces of art
1.Bible. N.T. – History of Biblical events – Art
2.Painting, European 3.Christian art and symbolism
I.Title
755.4

ISBN 1 85894 262 4

Translated, adapted, and augmented by Benjamin Lifson

Produced by Merrell Publishers Limited
Designed by Nicola Bailey
Copy-edited by Richard Dawes

Printed and bound in China

This book was published with the support of the French Ministry
of Culture's National Center for the Book.

Photographic Credits

AKG Paris
Jean-François Amelot / AKG Paris
Orsi Battaglini / AKG Paris
Cameraphoto / AKG Paris
Erich Lessing / AKG Paris
Joseph Martin / AKG Paris
Rabatti – Domingie / AKG Paris

NOTE ON THE IMAGES
*Some of the reproductions in this
book are cropped versions of the
original paintings.*

JACKET FRONT
Enguerrand Quarton
The Avignon Pietà
see pages 178–79

JACKET BACK
Fra Bartolommeo
(Baccio della Porta)
The Holy Family
see page 49